CW00539854

Phili Jagnan.

le 24 mai 2008.

à H.R.

Published in 2003 by
Stewart, Tabori & Chang
An imprint of Harry N. Abrams, Inc.

Text copyright © 2003 Pierre Gagnaire, François Simon, and Bénédict Beaugé
Photographs copyright © 2003 Jean-Louis Bloch-Lainé
Photography concept produced by Jean-Louis Bloch-Lainè, Marianne Comolli, and Yan Pennor's
over an eleven month period from January 25 to November 21,2000

All rights reserved. No portion of this book may be reproduced,
stored in a retrieval system, or transmitted in any form or by any means,
mechanical, electronic, photocopying, recording, or otherwise,
without written permission from the publisher.

Library of Congress Cataloging-in-Publication Data available upon request.

ISBN-13: 978-1-58479-316-8
ISBN-10: 1-58479-316-3

Printed in France

10 9 8 7 6 5 4 3 2

HNA ▪▪▪▪▪
harry n. abrams, inc.
a subsidiary of La Martinière Groupe
115 West 18th Street
New York, NY 10011
www.hnabooks.com

PIERRE GAGNAIRE

REFLECTIONS ON CULINARY ARTISTRY

by Pierre Gagnaire

Captions by François Simon and Essay by Bénédict Beaugé

Photographs by Jean-Louis Bloch-Lainé

Book concept, artistic direction and design by Yan Pennor's

Photography concept by Jean-Louis Bloch-Lainè, Marianne Comolli, and Yan Pennor's

Stewart, Tabori & Chang

New York

Table of Contents

5 Introduction (Pierre Gagnaire)

8 Sweet

107 Discussion on the Cuisine of Pierre Gagnaire (Bénédict Beaugé)

128 Savory

237 About the Authors

239 Acknowledgements

« In the end,
it is all about love. »
— Joseph Delteil

I learn to cook, I have cooked, I like to cook….

In between these three inflections of the verb, thirty years have passed. I now understand that when I was first placed in front of the stove, it was without any real desire. I endured cooking and the techniques endured me; the love for the art of cooking came much later. Only now do I recognize that the tools and ingredients have proven themselves to be grateful! They needed to be listened to, watched for, seduced, tamed, and allowed to be themselves. However, using their basic nature was not enough, one must add some wit to the ingredients… and in doing so, I added wit to my awkward youth.

To cook is to labor. It is a repetitive task that is often arduous, sometimes thankless, and on occasion hazardous. However, it is also an authentic source of happiness when it evolves into creativity. For me, cooking found its true meaning when it ceased to be a blind repetition of methods memorized without discernment. Cooking only became daily happiness when I dared to refuse to use the same crippling approach day after day.

It was not a dramatic break with the past and its traditions. I consider each fundamental principle in classic cooking a needed step toward new thresholds: the modernity I seek. I choose to forget methodology while, at the same time, based on my observations and my knowledge, I reinvent a technique so it appears more truthful. I see this process as a dialogue with the past, and I make it my daily reality.

Creativity is born from authenticity, but it is supported by tradition. An artist does not reinvent the rainbow; he uses the colors in a different way. Patiently, and after long consideration, my work has found its way, nurtured by precision, coherence, and common sense, and also by the unexpected. We are not talking about creativity for the sake of creativity. It must make sense, be efficient and enthusiastic, but at the same time restrained. There is a fine line separating a creative dish from one that is excessive or even ridiculous.

How far can you go? This is where the anguish begins! One must define the tempo of the craft with great rigor and with honesty, and set the boundaries. It is necessary to fight against conformity and fashion. Just as a blank white page calls out for writing, the emptiness of a white plate is the beginning of a dish. Born from silence and concentration, the dish asserts itself, demands purity. White is the symbol of innocence, the overlooked,

and the emptiness that precedes beginnings full of possibilities. That is the origin: this supreme moment of peace that precedes the one of motion.

Cooking is like jazz with its rhythm and dissonance. I like the silences, a genuine breath announcing a strong movement, one that makes the notes vibrate. I like the doubts of the musician, his awkwardness. I like his wit, his childlike laugh, and his sensual rapport with the instrument, his intoxication with the notes that leads him to the sublime. Also like jazz, cooking demands humility, but with a touch of arrogance. It requires a pinch of oblivion to be able to write its own score which fades away without nostalgia as soon as the note is played, as soon as the dish is created.

The composition of the plate is a candid summary of a life with its dreams, its weaknesses, and its excesses. There is something reminiscent of childhood in this freedom without deceit or artifice. The labor then brings happiness to oneself and those that consume it—the essence of creation. The creation succeeds only if the result inscribes itself as the essence of beauty and good taste. Because after all, as Gillet once wrote, "What is good? Isn't it the fragile osmosis between the taster, the desire, the chef, the service, and the efforts to obtain a beautiful work?"

Through the words of others, I discovered that cooking could be a source of creativity designed to give pleasure and, possibly, make people love you … I realized that words have power—they see, they listen, they taste. The words embrace the flavors. They summon sensuality to the point of eroticism and arousal of desire. All that was not imagined or anticipated, the true truth: one does not gingerly enter in my culinary universe.

Please, no false courtesies, no contrived universe, no proper bourgeoisie. My Epicurean world communes with everything that speaks of feelings, pleasure, and knowledge. I am looking to master my innovations while keeping an eye on the technique and the discerning knowledge I have acquired. Not just to have an innovation be something new, no fashion of the day, but rather an open mind into a true creative world.

One last thing: we are not talking about a cuisine of enlightenment. Rather it is a cuisine of passion. Such is my work. Such is my lifestyle. Such is my life.

Pierre Gagnaire

SWEET

Crisp tuile of
reduced orange
juice molded into
a ring to hold a
grilled langoustine.

WAIT.

A n ingredient does not commit itself immediately. You have to wait for it, catch it. Thus, this jus of an orange transformed into a lacy tuile. You have to let it be impatient, champ at the bit, exasperated, until finally it finds its way. What is it waiting for? One beautiful grilled langoustine! Although working with sweet ingredients is ruled by strict guidelines, you have to slowly let it find its purpose. It is never a matter of urgency. Black currant jelly cannot be rushed. Slowly, the berries playfully burst in the syrup. You just have to let them be. Wait, and in the end you will be rewarded with their magnificent simplicity. The dessert must wait for its time, not just follow the rules of the nice-looking and well arranged. I like apple tarts to be a little battered, a little sloppy, but so good, so sincere. More than that, I believe that to touch people, you must forget silverware and tablecloths, go straight to the senses.

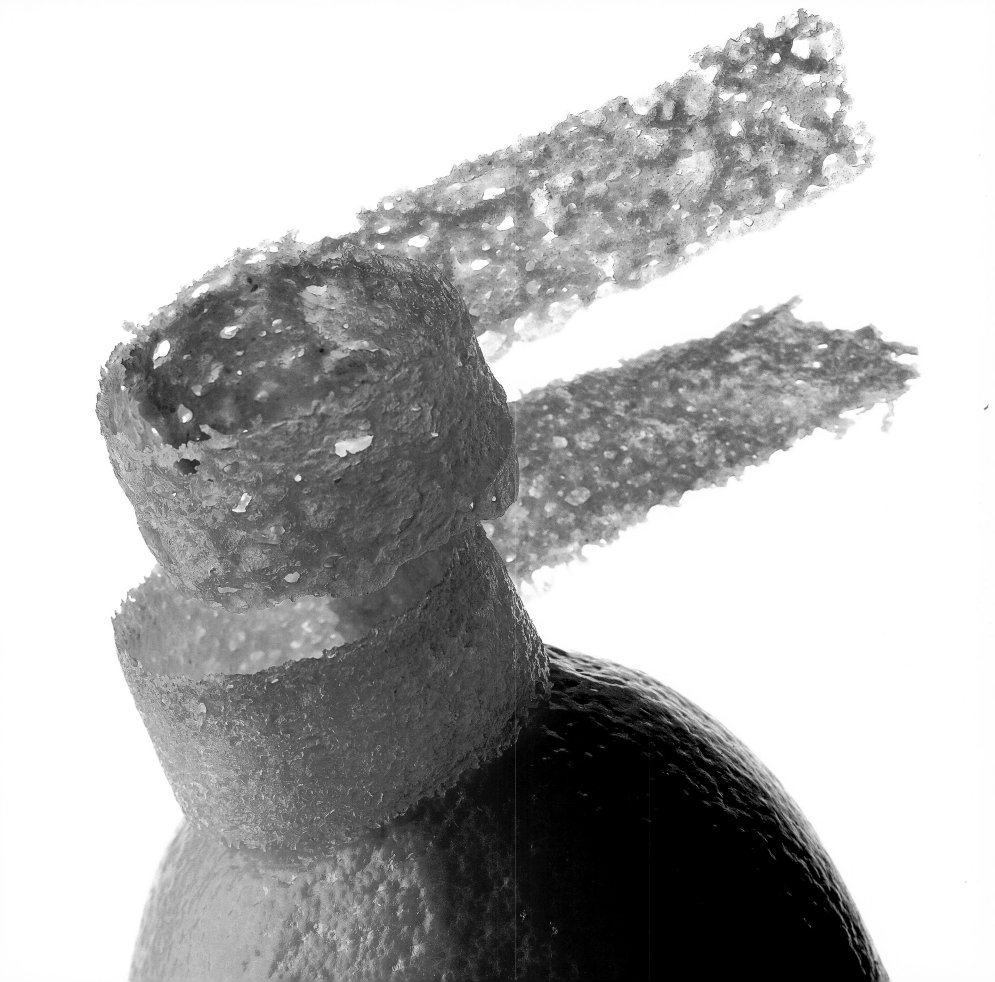

Harmony of colors,
contrast of flavors:
blood orange with its
raspberry flavors,
peppery nasturtium
flower and its tangy
leaves hiding droplets
of hibiscus gelée.

THE ALIBI OF BEAUTY.

12

O
One can easily be satisfied by pretty compositions
and sail tirelessly in the ocean of loveliness.
You can imagine the picture: a schooner, seagulls
like commas against the sky, a lighthouse. But it
is after the initial stroke that beauty appears, like
dew in the morning. During the night, tastes
have melded, evolved. The dish has done its work and now bursts
onto the scene. The aesthetic in a dish is part of its soul and
satisfaction. More than an accessory, an afterthought, the aesthetic
follows along, lurks, waiting for its time. I cannot conceive of a
runny sauce; I immediately bind it. Or a sloppy ham and butter
sandwich; I will assemble it into a neat cone.

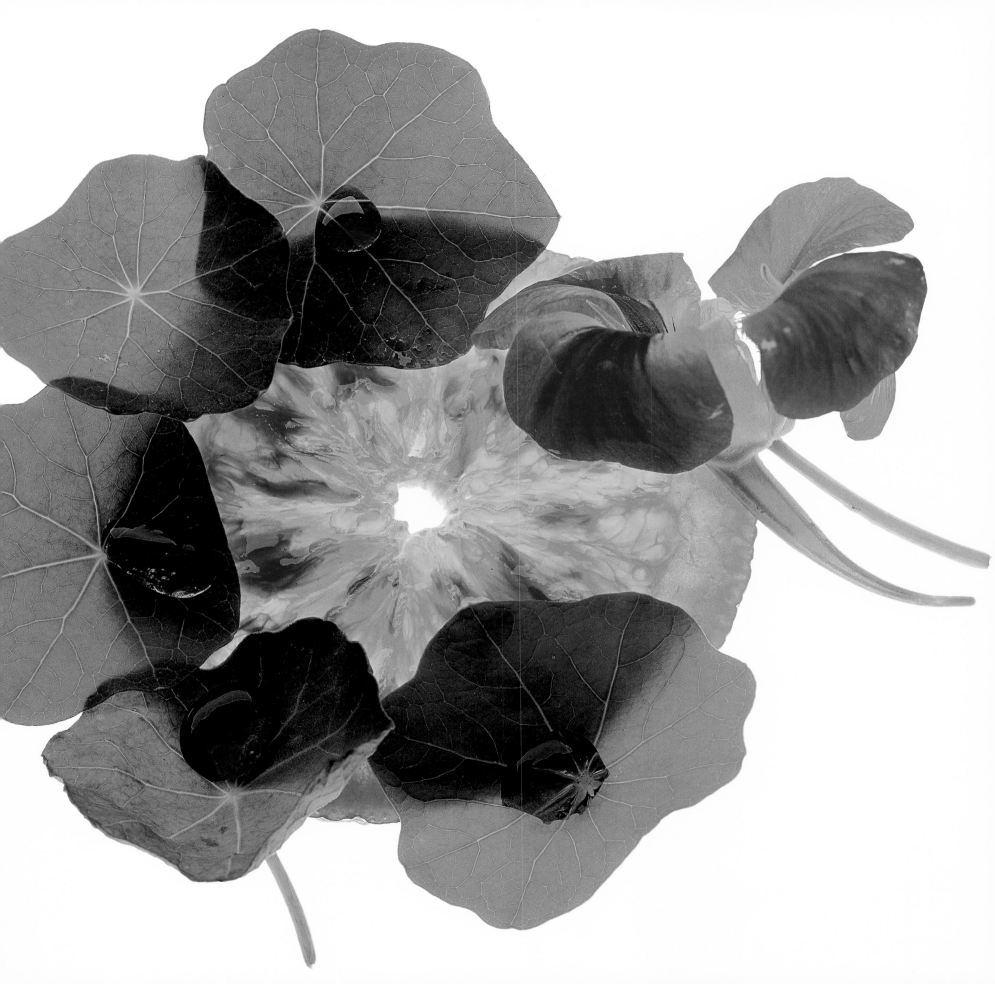

Turkish delights
French style:
unctuous marshmallow
flavored with roses,
aroused by the
pungent and wild scent
of fresh rosemary.

AN INTIMATE WORLD.

14

I take no pleasure in mullet Big Macs or tuna burgers. Pointless provocations don't amuse me. If I choose to slip some marshmallow into one of my desserts, it's for its fresh or playful character. For me, what at first glance seems commonplace often contains a larger complexity. Here before me sits this small pastel cube. In it I read an invitation, a puzzle. As a result, I have introduced it to a series of desserts from chocolate and fresh thyme tarts to blackberries and fig paste. What I love about marshmallows is their surprisingly tender bite. The endearing texture leads you within a soft, gentle universe. Cuttlefish, squid, and calamari bring me back to that same place.

The pink bursts
of a mauve-colored
flower and those of
a translucent slice
of beet emphasize
the deep purple of
a tamarillo sorbet.

FOR EYES ONLY.

16

I mistrust flowers in cuisine. Strangely, their role has never truly evolved. They are still more or less anecdotal. It would be interesting to know why. Too pretty? Too civilized? On the palate, they have a short finish, piquant and velvety. Still, I've yielded to the aesthetic pleasure; the mallow flower inevitably calls out to the sorbet of tamarillo, an exotic fruit that expands exactly on those flavors—velvety, piquant.

Almonds, hazelnuts,
pistachios …
like precious stones
set in transparent
lacy egg whites.

IT'S ABOUT TO START

18

S ometimes, taste seems to rise by itself for no obvious reason. That's just the way it is. At other times, I feel as if there is a stillness to respect, a moment of silence. Everything quiets down, lowers itself as if waiting for an element to come and talk, ring the bell and call out. Perhaps something to provide for this hazelnut and pistachio nougat. The hazelnuts and pistachios would like to say more, but the egg white says: "Hush! It's about to start." What? Red berries, honey, an Alizier (bitter almond liqueur) syrup.

CALM.

20

From time to time, it is necessary to slow down, to impose a certain serenity. To take an empty space and only fill it with bare necessities. A white chocolate Martha, a little lake of red currant jelly. That's all. That's everything.

THE OPPOSITE EFFECT

22

Tarts are fleeting creatures. That's why they can be sublime or depressingly banal. When we see them emerge from the oven, hot, vulnerable, crisp, we are almost indebted to this vision. We know them to be exquisite, so it is a matter of making every effort to preserve that moment. Air, fruits, the pastry cream, are essential to the tarts but they also shorten their magical appeal. This is why at the restaurant we make them á la minute, fresh for every order. We treat bread the same way. Two batches are planned for the dinner service: one for the beginning, the other around nine-fifteen. Each creation has its own life, and it is often brief. Not respecting this will quickly make them go flat, like serving sparkling water that has been opened the day before.

Strawberries caught
in the ice of a
translucent cooked
sugar flavored with
cinnamon and orange.

ALONE IN TOWN.

24

S ometimes, the quest comes to an abrupt halt. Everything goes blank. Suddenly, I live in a strange town, and within the four walls of my head I keep searching for answers. I'm not blessed with a salty bay, a mountainside rippling with herbs, a trove of rare mushrooms. So I watch, I observe. These wild strawberries have long tormented us. How to sublimate them, exalt them, and carry them toward a lovely destiny? The idea came on a beautiful morning. A disc of caramel laid over a scattering of strawberries. The caramel melts in the heat, and all of a sudden the strawberries are transported into a circular formation. You can pick them up with your hand, bite into them like a mendiant of dried fruit. They have retained all their spirit. As for me, I have pursued my own.

Warm, suave, juicy:
a Victoria pineapple
furrowed and
sowed with sugar
and vanilla seeds,
slowly roasted.

THE NARCISSISM OF THE ULTIMATE

26

This Victoria pineapple gives the impression of parading nonchalantly, as if it just came out of its hammock. However, it has just gone through a relentless preparation—it has been seduced, massaged—the multiple cooking procedures were long and mindful to ensure the perfect doneness. The pineapple is neither overcooked on the outside nor raw in the center. We also had to resort to the cleverness of the star anise, Kirsch, vanilla, and a light sugar syrup. Now it shines and shows off. The pineapple is proud but obviously slightly worried—we are going to eat it!

Perfectly luscious:
thin slices of pears
roasted in a butter
caramel, punctuated
by muscatel raisins.

THE SONG OF DEPARTURE

This superb sauce has such a seductive appetite, it could take over the page. The sauce is the result of skillful technique, a fruit caramel reduced with butter and sugar. Everything rushes to answer this appeal: roast pears, little muscatel raisins. . . .

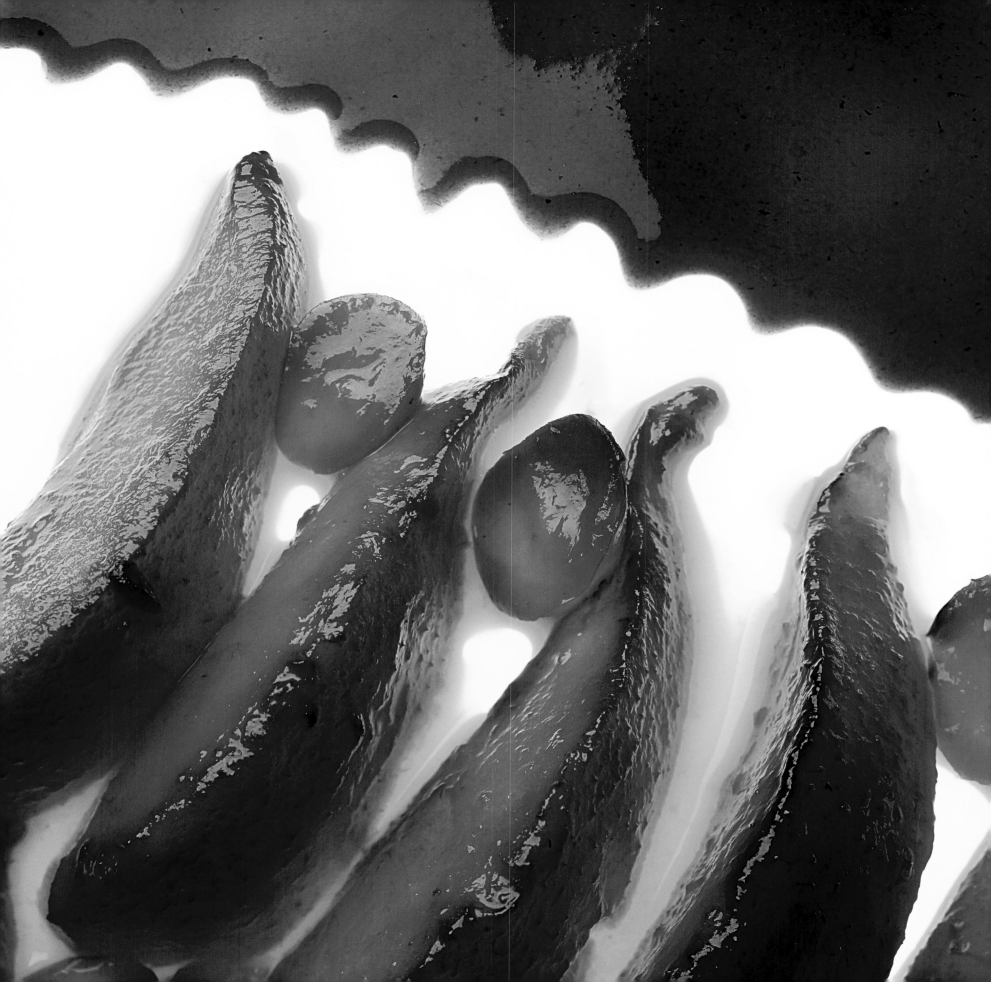

Everything caramel:
a tuile hiding
crystallized Kirsch, a
shell for a wedge
of pineapple, a bed
of sparkles.

NAP.

30

There are many different varieties of pineapples. Most of us only know the unattractive aspects of the fruit: its toughness, its sinewy flesh. But with the Victoria pineapple, everything changes—the planet is knocked off its axis. This is the true pineapple: juicy, heady, suave, sensual. It is such a pleasure that its languid rhythm draws inspiration. I roast the Victoria on the rotisserie. The process is slow, like a long nap in the rhythmic sway of a hammock. Ultimately, it delivers a moment of pure pleasure.

The red of a strip
of pepper confit
embracing a kumquat,
the black of a bitter
chocolate cake; just a
stream of raspberry
cream to unite them.

INDESCRIBABLE.

36

Y ou may think that everything has been said about chocolate. Yet its seduction is so potent, there is always more to say. Chocolate carries me through the seasons. What you are looking at is a late-winter creation. Red sweet pepper (a perfect marriage with wine), kumquat. . . . One thing that this picture cannot convey is the many textures: unctuous, crispy, creamy, crunchy . . . there are at least six of them.

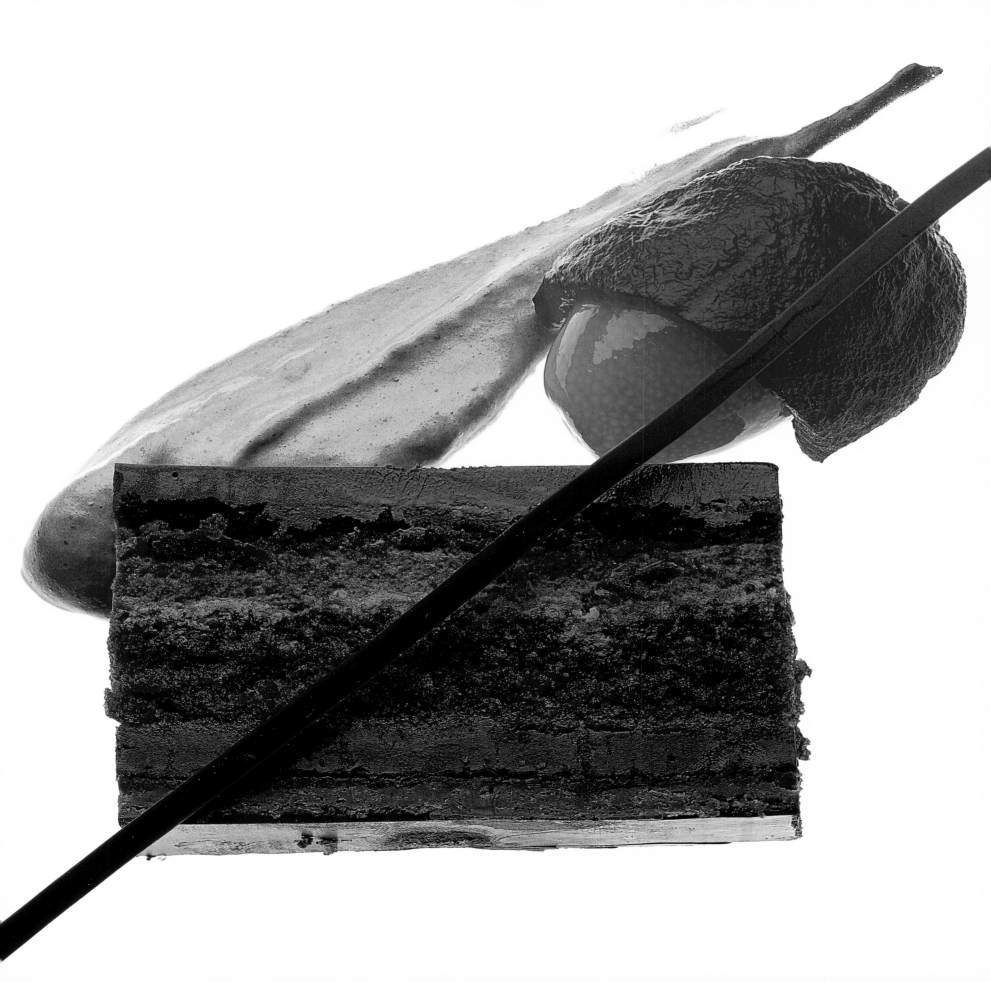

Under a black crust,
the blond airy inside,
smooth and opaque,
of a tourteau fromagé.
Redirected, this divine
dessert will accompany
stuffed vegetables
or lobster.

Suddenly.

38

Sometimes associations with ingredients are inevitable. This little-known cake from the Vendée (goat cheese pastry) is delicious. Is it sweet or savory? What do you associate it with? Café au lait, cherry preserves? No, I decided lobster.

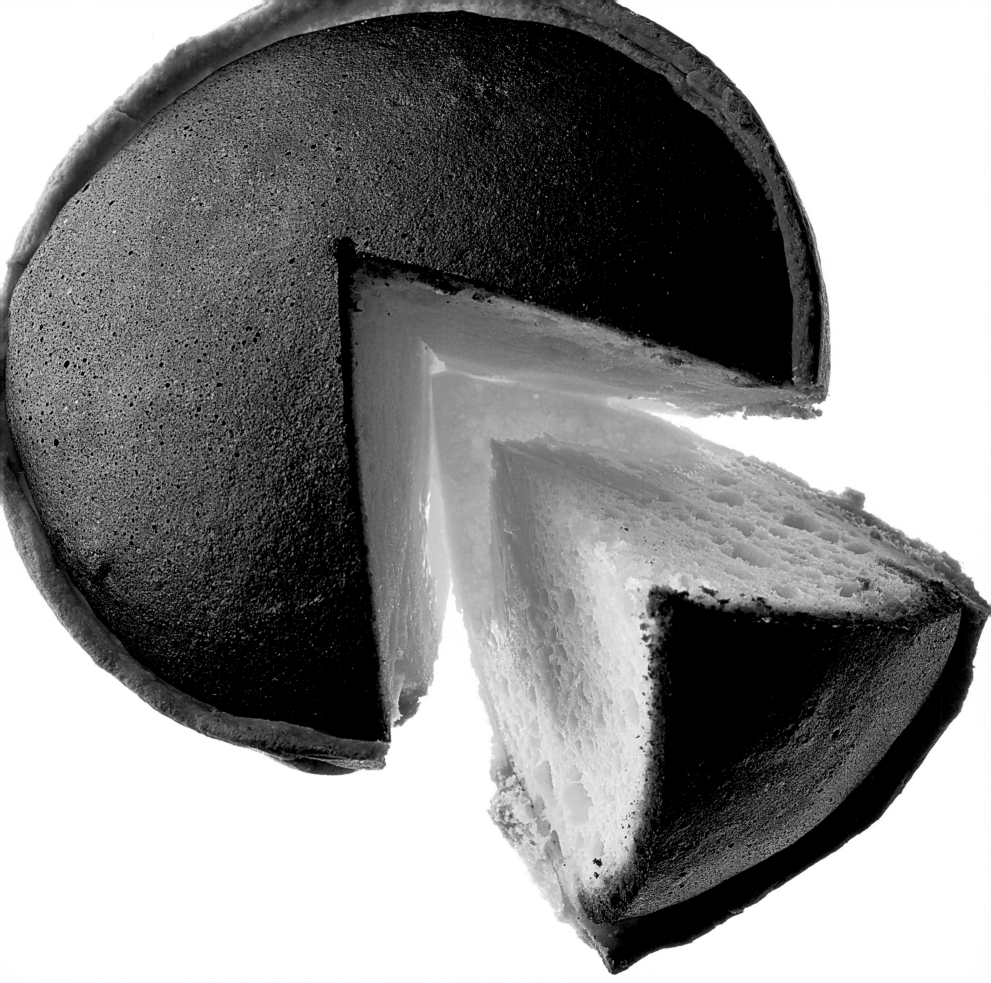

The chestnut antholo-
gy: confit layered as a
terrine, garnished with
caramelized walnuts
in a light orange mous-
se, accompanied
by an orange coulis.

CONCEALED PECULIARITY.

40

This chestnut parfait, traced by a serpentine made, among other things, of blood oranges, could easily stir a devoted following among patrons. However, here a new dimension—the bitter taste—sneaks in and almost capsizes the boat. When you mention bitterness in the context of a sweet or savory dish, people often twitch their nose, but that is misunderstanding the sensorial role of this element. Once tamed, it transcends its annoying qualities and becomes a mute note. I compare it to a counterpoint in jazz, a sublime section of a piece of music. The bitterness throws the dish out of sync while underscoring it fullness. That is its concealed peculiarity.

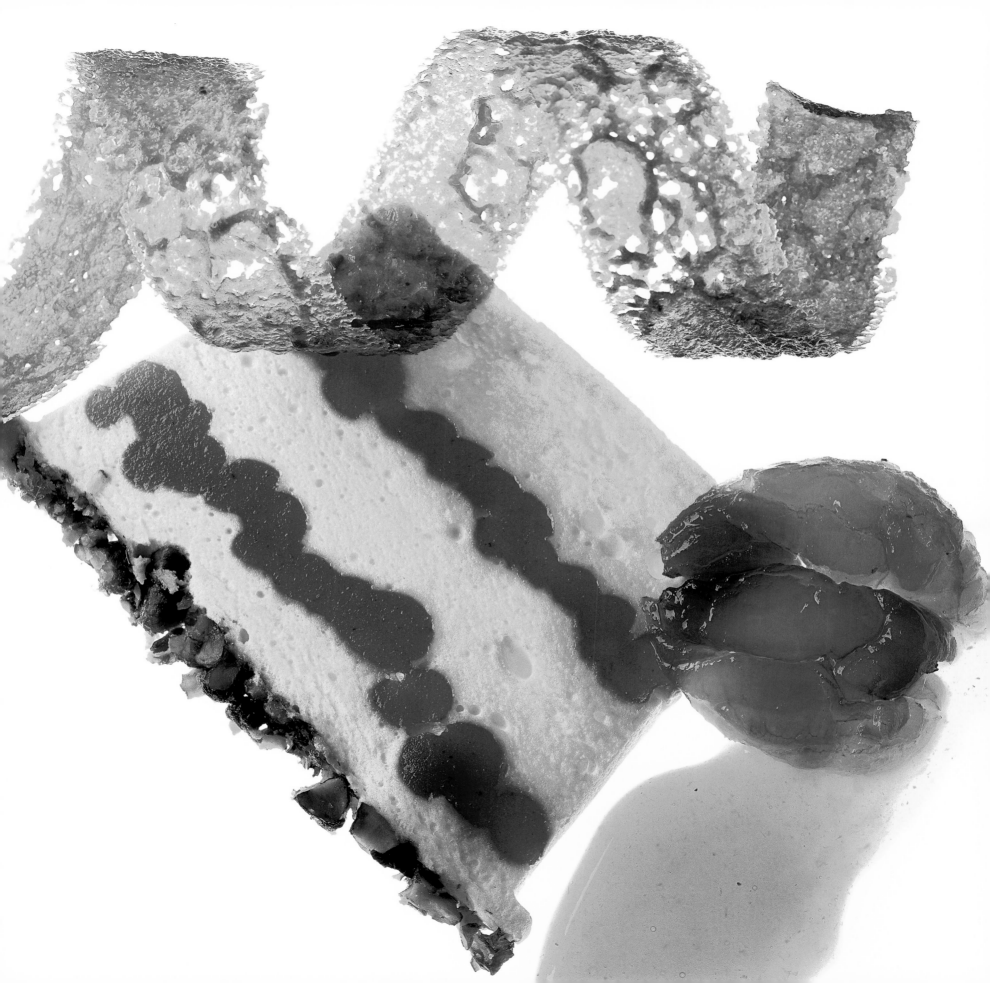

Incandescent red
of a pomegranate
and opaque red
of a quince confit
accompany a
sichuan pepper
ice cream and a
quince gelée.

ELIMINATE.

42

It is sometimes necessary to be wary of supporting roles. They give the impression of being props or nothing more than understudies. In a dish, a supporting role cannot undermine the lead (here, an orange sorbet or olive oil would be suspect). It is then bound to become a counterpoint. Not overwhelming, it must carry the dialogue like an echo. I am at a stage in life where my cooking has become minimalist. My attention goes to the justification of every ingredient on the plate. Keeping my spontaneity, I work with this emotion without pretending to rewrite the *Larousse Gastronomique*.

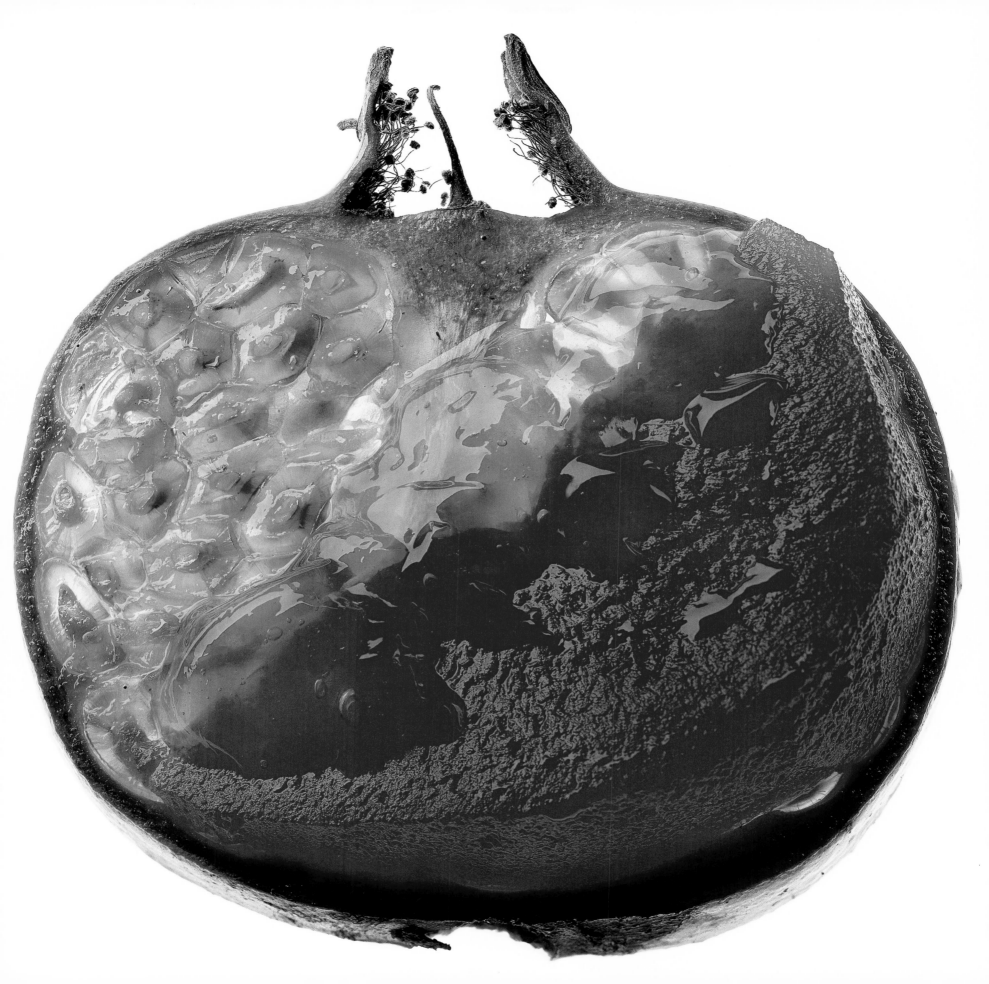

Chocolate Pokémon
and its orange sauce
capped with orange
zest and celery confit,
its wings, doted with
cream, spread out.

DEFEAT THE DESPOTS.

44

Chocolate is imperial. On a plate, you want to define its space, otherwise it simply takes over. To avoid turning this tyrant into a despot, you have to compose a pleasing, entertaining court of elves, fools, acrobats, and jesters. Some celery, or, more to the point, an orange juice with distinct character. Its subtle bitterness—we squeeze it with its seeds in an extractor—gives the dish its very structure, and, at the same time, a strange sensuality. Of course, the chocolate will receive all the applause. But that is another story.

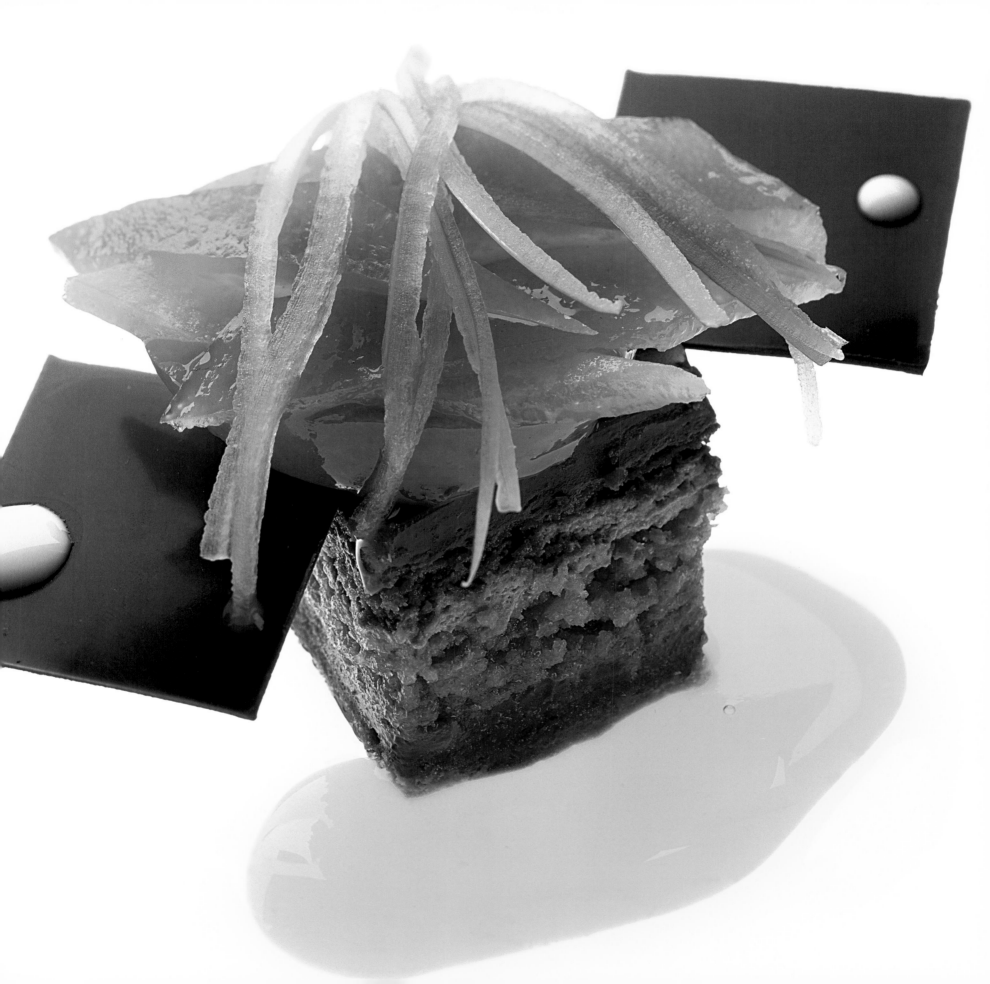

Eulogy of the fresh
pistachio: translucent
tuiles in the shape
of organ pipes,
unctuous sauce, and a
moist little cake.

HUSH!

46

A quiet landscape at the end of a meal. This pistachio petit four is here to calm the appetite. A petit four does not want to speak louder than the others. Supported by impeccable ingredients, here pistachios from Sicily, it brings serenity. It is as if it is whispering, "If you like me, try me."

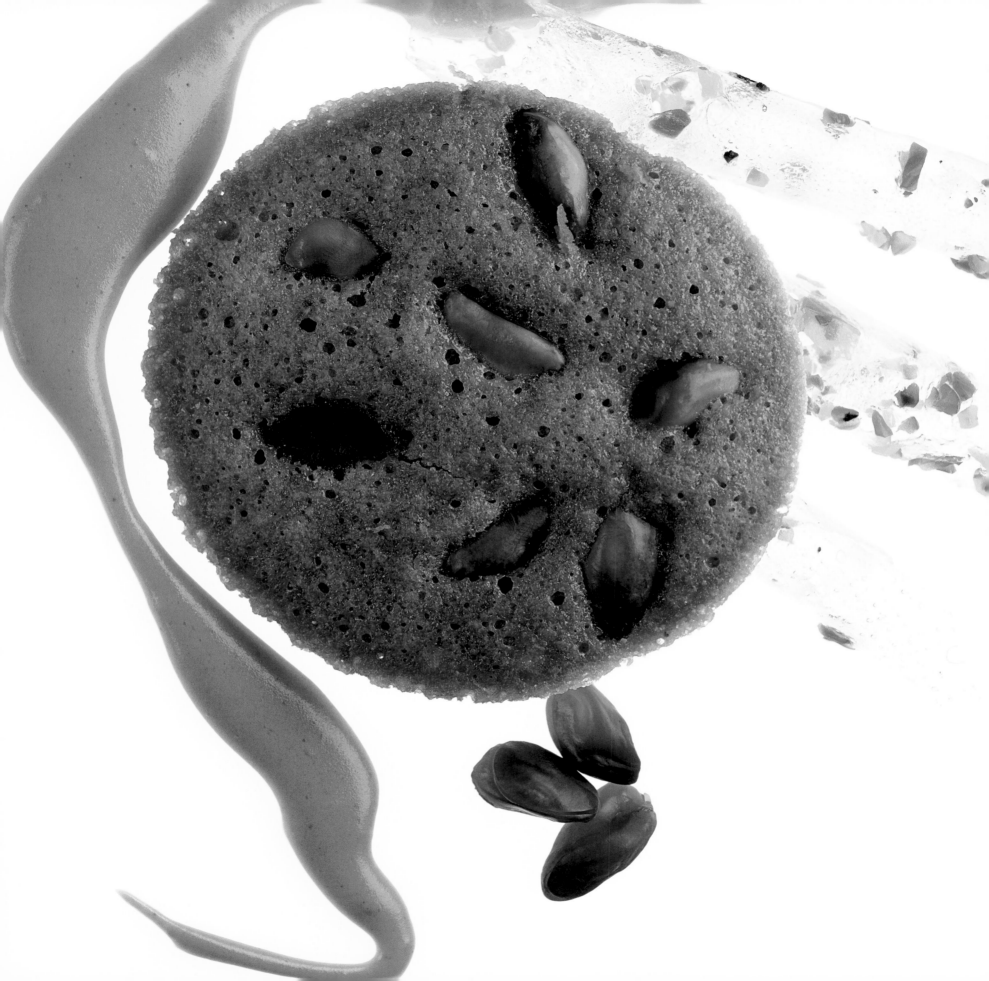

The ice plant—in a salad
that makes the taste buds
shiver with its thousands
of crystallized droplets—
accompanies a tartlet
marbleized with dark and
white chocolate, garnished
with red currant gelée and
a cloud of mascarpone.

WHISPERS.

48

By the end of the meal, it stands to reason, the appetite has been stimulated, seduced, bustled around, and quite simply sated. And nevertheless, that's the moment sweets are meant to appear. Imagine the musical score! This is why petit fours are small. They just seem to slip into your field of vision. They slow down the moment, quiet it to a whisper. Or at least they seem to. Petits fours need to be witty. This is not the time to offer soggy tarts or overloaded cookies. You have to appeal to the intelligence of the guest, pique his or her imagination. Here we have an ice plant. Its leaves are plump with water. They will embellish a tartlet that has just emerged from the oven. Working quickly, the miniature tart is brushed with black and white chocolate, and topped with a dot of mascarpone. Petit fours belong to that strange family that stirs the appetite. They revive and amuse us.

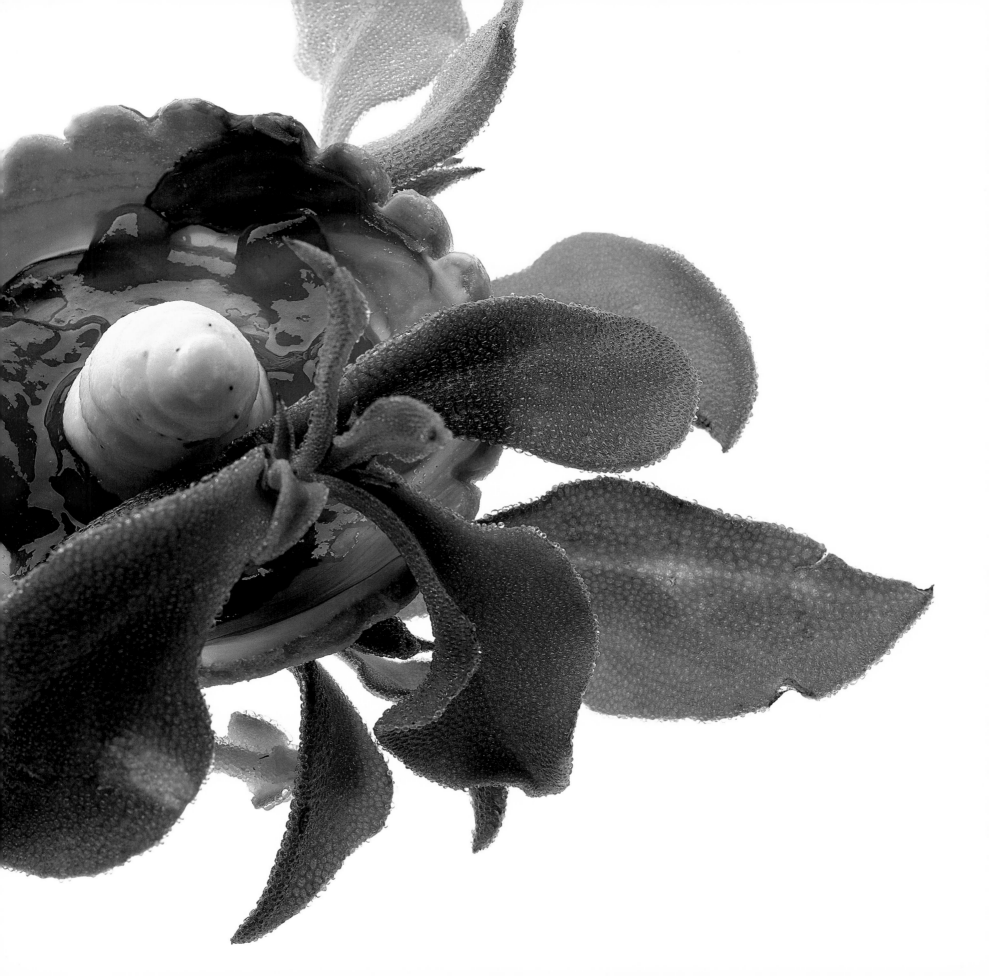

In between the pear
and coffee: a fruit
confit in its skin, all
wrinkled, a delicate
tart, a tuile like
a disheveled ribbon.

TO REMAIN A PEAR.

50

Skin, bone, these are intricate parts of a product. Cooking a fish without its bone is taking away its complexity. This is also true of a pear. Case in point, here the pear has been poached in a silky marinade of tea, wine, orange, lemon, and syrup, while retaining its personality. Drunk on red wine, wrinkled, transformed—but always a pear! It has been scored, sliced, reconstituted. The peel, the rough side of the fruit, remains. It is still a pear.

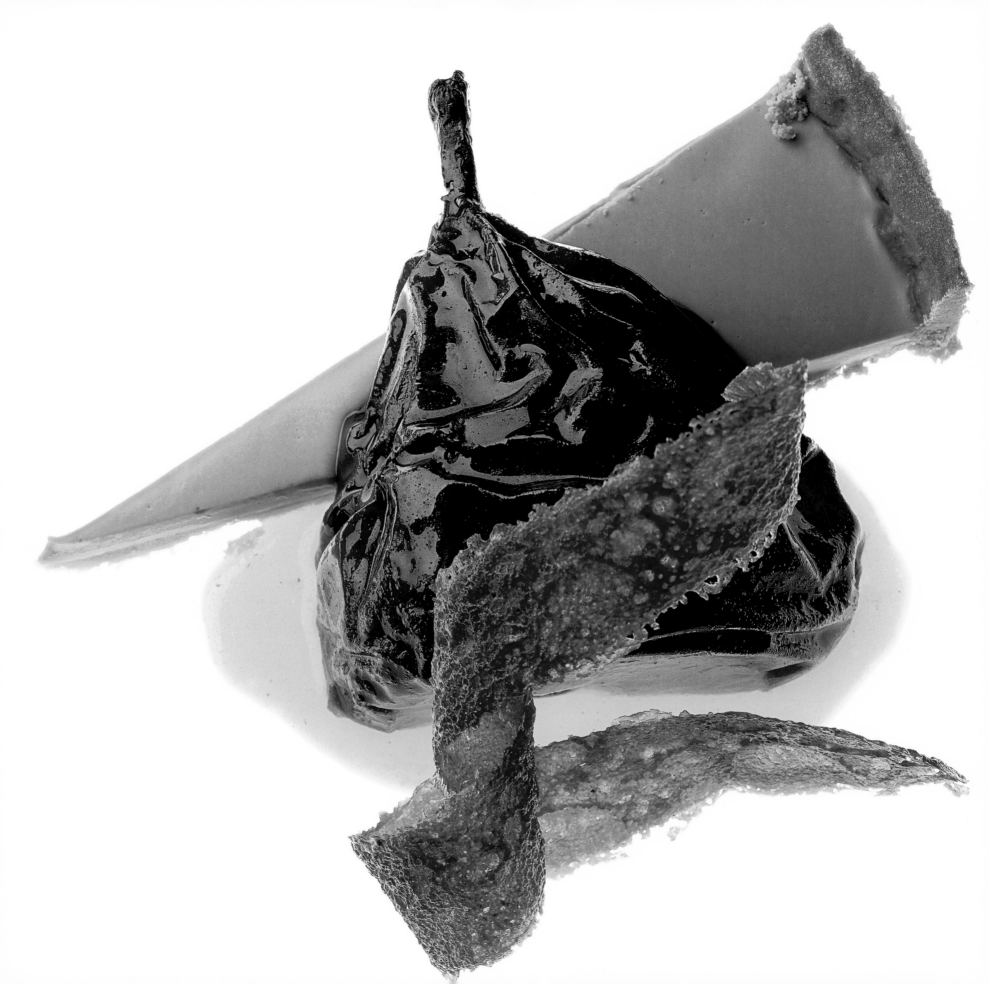

On a bed of beads of
tapioca in coconut milk,
a conjugation of the
lemon from Menton:
slices of confit, opaline
tuile flecked with the
zest, in the syrup
imbibing a cake.

A Continent In Steam.

52

W hen the chef labors over his pots, familiar continents appear amid rising steam and aromas. In this imaginary world, you create a perfect likeness, with singular outlines. Take this composition of tapioca, cookie, and lemon. To me, it summons up the spirit of Italy. Although I have a particular fondness for the punchy, powerful, muscular dishes of Spain, Italy to me exudes elegance and softness. Curiously, it is a lemon (it hails from Menton) that seals this alliance, infusing the composition with the refinement of Italy.

Underneath a hat of
caramelized pecan,
milk chocolate sweets
encrusted with
Griottine cherries.

THE PECAN AND ITS MISUNDERSTANDING.

54

Once again it is all about quantity. This toasted and caramelized pecan needs a light companion, and it finds one in this milk chocolate. They'll go the distance because they are not overloaded. I think that pecans are often distributed too densely through a dish. I remember a tart with so filled with pecans it was unpleasant, heavy, filling. And yet, in certain dishes, I prefer the pecan to the bitter walnut, whose astringent qualities disturb me. Pecans are pleasant, with an almost round, plump quality. Presented this way, they find their voice, their song.

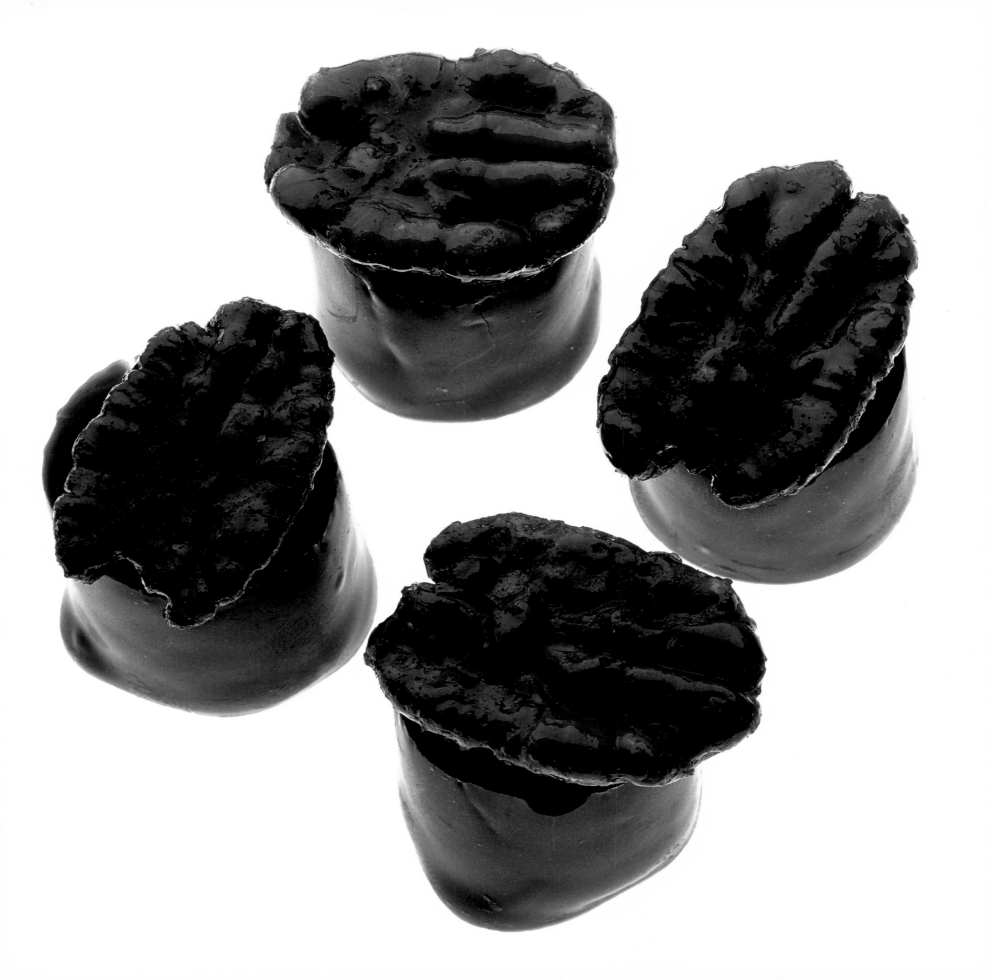

Scents of a
caramelized jumbo
apricot, surrounded
by a pistachio
touron and a small
lacy tuile.

CHARRED.

56

Sometimes you have to push ingredients, like this apricot, recklessly toward flavors that will show them off. Charred flavors are intense (like that of aged game meat, overripe fruit . . .) from which, pushed to the limit, a kind of truth springs forth. These are the flavors taken to precise extremes that only the hand of a chef can deliver. One step further and they are ruined.

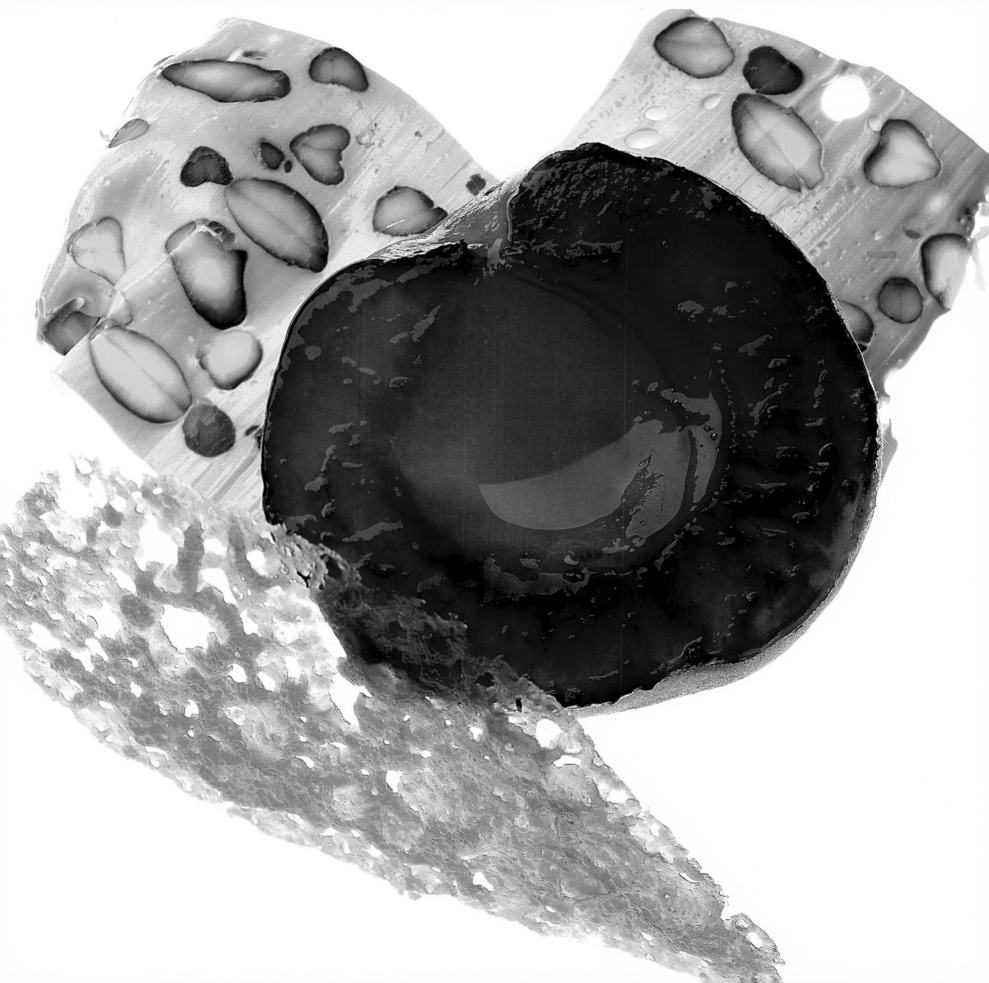

On a bed of licorice
sticks, in caramel
shell, a prune stuffed
with a salpicon
or small dice, of
seasonal fruits.

DON'T SAY A WORD.

58

When it comes to dessert, I am a team player. I start the creative process and immediately my team gets cracking with its know-how, intuition, and techniques. We understand each other without a word. Here was a prune whose character needed to be captured. Immediately, Didier, my pastry chef, envisioned a shell of caramel, chiseled with a blowtorch. This dessert has a life span of just five minutes. It's delicate, unctuous, full of flavor. I am very proud of this dessert. We have done very little testing; it just sprang to life complete with its licorice stick, caramel. . . .

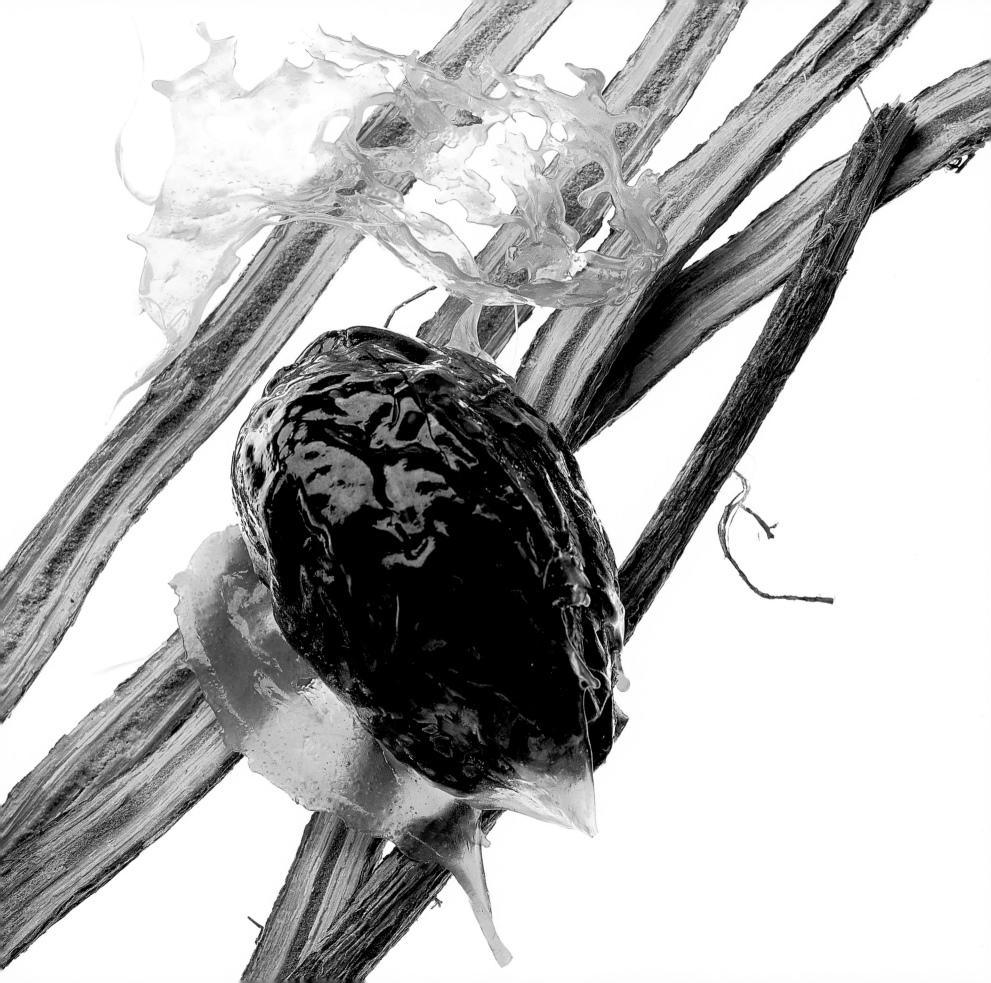

On a sheet of
translucent crisp brick
(a dough similar to
phyllo), a superposition
high in tastes and
colors: lemon confit,
raspberry compote,
tomato in syrup.

TWO SPLENDID KILOS.

60

Some foods wait like wild animals at the edge of the forest; others arrive suddenly, like magic. I was working on a theme for a menu based on the tomato when I found myself with two kilos of superb tomatoes. They were magnificent. What to do with them? First, I thought I could not use them in any commonplace way—I wanted to surprise people. Tomatoes, then confit lemon, and strawberry compote. The detours are the major ingredients in cooking.

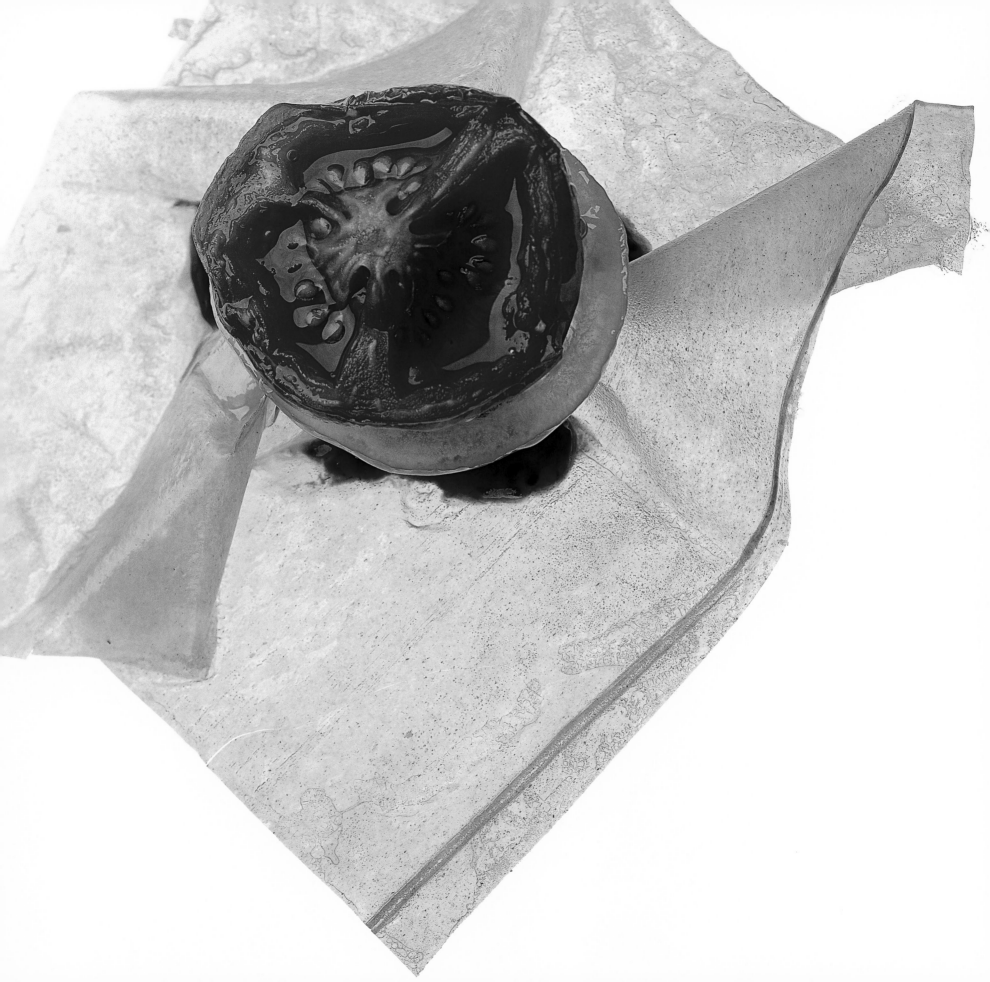

The roundness of
an infused baba,
glazed with apricot,
stuffed with an
angelica cream.

THE MOTIONLESS DANCE
OF THE NABOB.

62

Of all desserts, the baba au rhum is the most accomplished. This is, quite simply, because it successfully balances complexity and simplicity. You have to see this motionless dance in which the cake allows itself to be overwhelmed by fruit, cream, and syrup. The syrup must be perfect; it is the leader in this unique dance. It is perfumed, permeated with the subtle precise flavors of cinnamon, bergamot, and pear. The syrup gives its character to the cake, which gladly immerses itself.

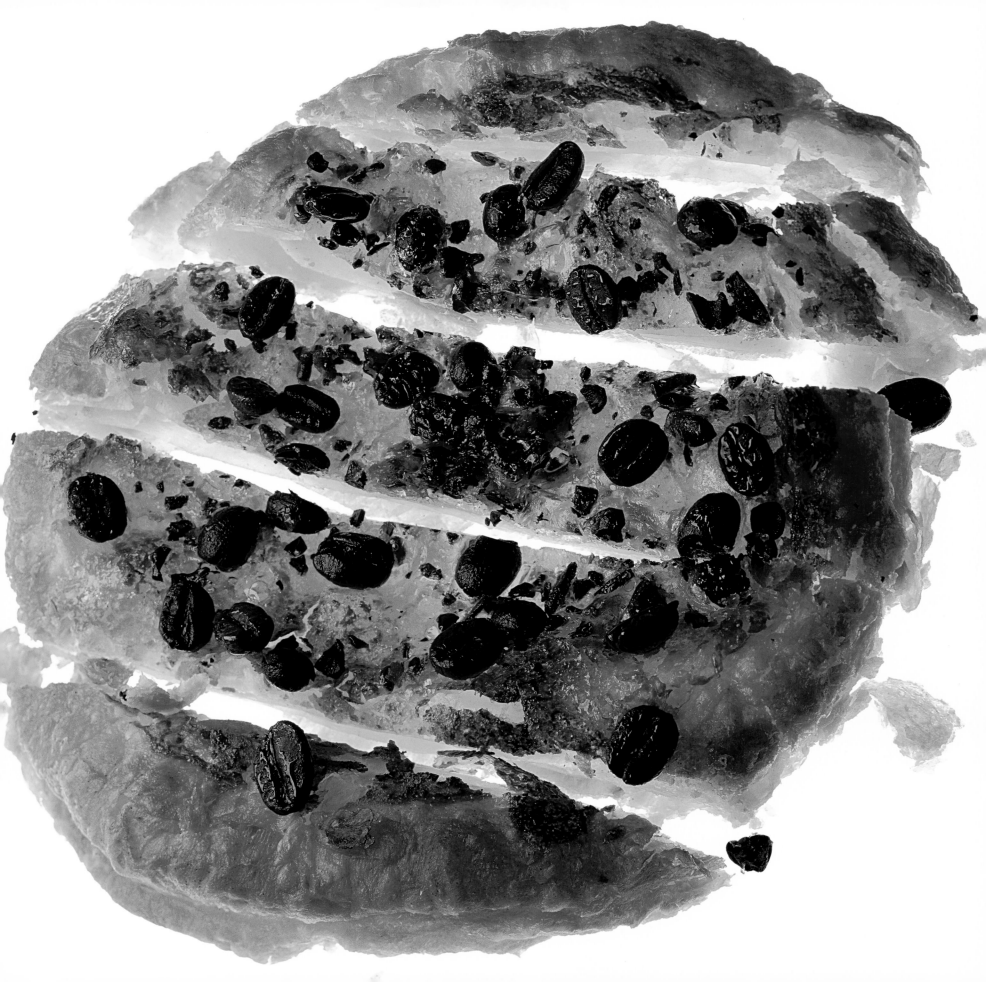

A few crumbs of
butter cookie reveal
the contrast between
a red apple soaked in
saffron syrup and a
raw green apple.

THE ART OF POACHING.

68

Poaching an apple is one of the simplest gestures in dessert making. And yet, it is very easy to go wrong with this technique. Poaching requires an amazing amount of patience. I start with a simple syrup flavored with grapefruit or pear, then infuse it with saffron. The apple is then poached in this syrup for two hours. I refuse to core the apple, keeping all of its taste and character intact. If it cooks too fast it will fall apart. It's a matter of protecting it, letting it soak up the syrup: the transfer must go off like a dance, without jostling, without haste. I prefer the Gala apple because of its crisp, even texture and because it is not watery. I serve it with a crisp counterpart of julienned green apple. A crumbled shortbread cookie contributes its crunchy note.

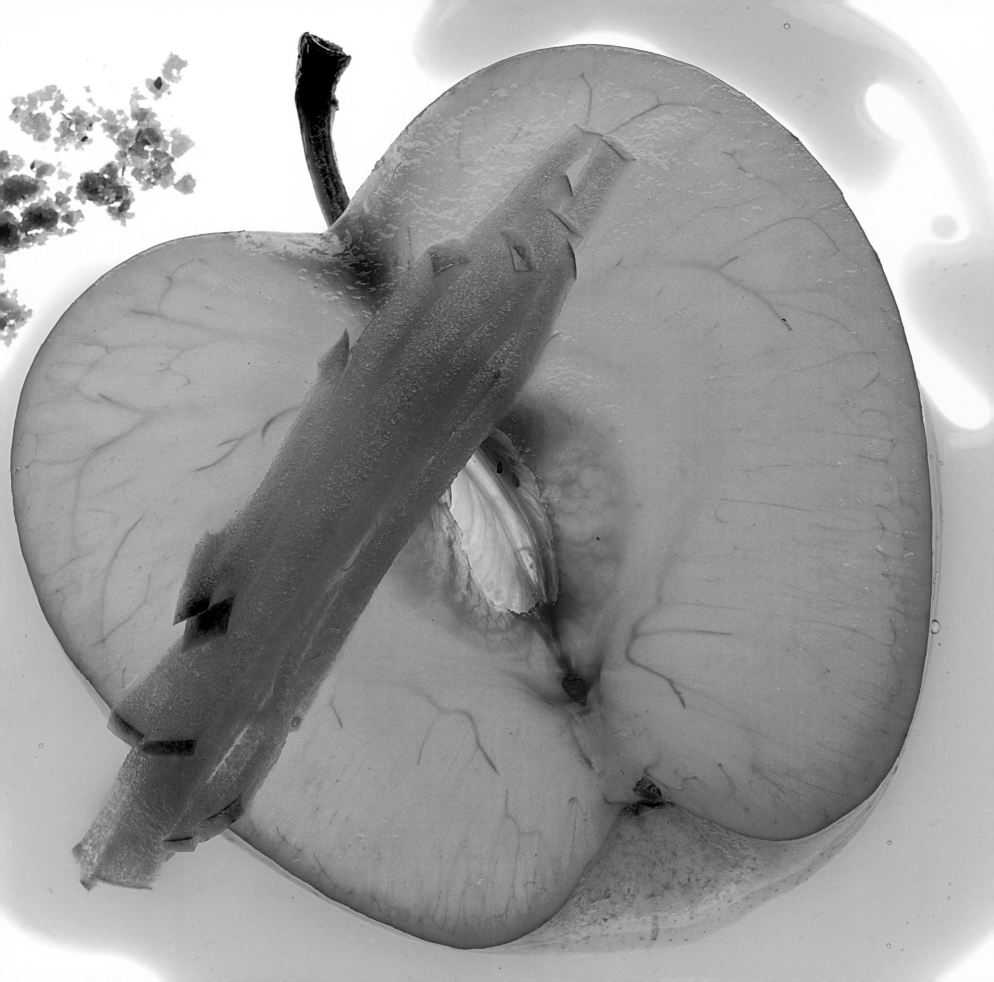

Artichoke heart, glazed
and flavorful, in a
moist cake surrounded
by a walnut caramel
and a praline sauce.

THE VIRTUES OF TRAVEL.

70

J Well, I've almost forgotten this cookie and its chocolate chips. Meanwhile, I've been somewhere else. I've forgotten everything, including this creation. Today, I'm looking for something else. There are these little spiky artichokes. Now, take away the praline flavor, move the artichoke into olive oil… Let it marinate in its future.

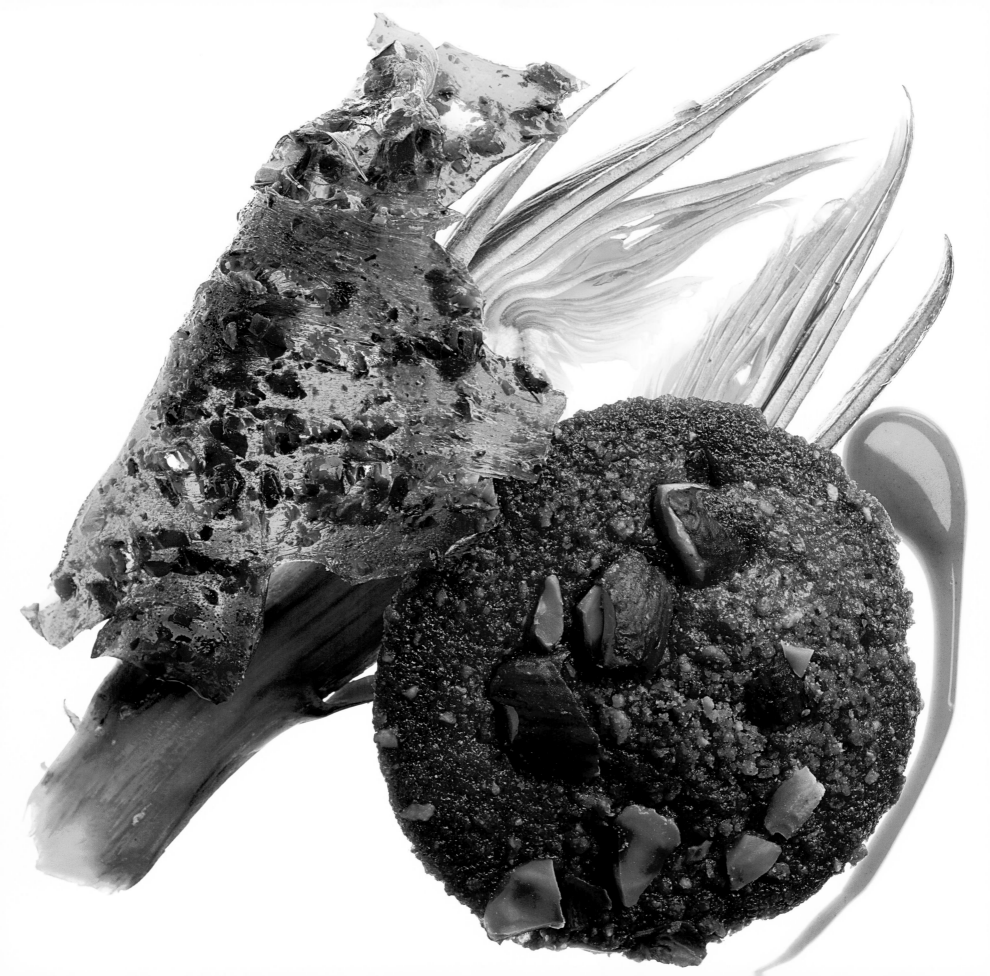

Abstract transposition
of a dark chocolate
tube associated with
coconut cream.

BLACK SPOT.

I don't trust chocolates that conclude the meal. When they arrive heavily, imperiously, they border on heresy. I have a great respect for chocolate. I like its lively, fragile, brittle, and bright accents. I like it less when it launches into themes too dark, too obscure, precisely when the rainbow fades and the chocolate becomes the black spot. Chocolate should play with panache and elegance. This is why you must follow it, tame it before it starts to grumble.

Chocolate bar flavored
with pralines,
encrusted with crumbs
of a crisp cookie,
brown sugar, and
caramelized almonds.

CATCH THE THIEF!

74

Granted, you could say that this chocolate is alive only because of your desire. It is about to make a fleeting apparition. Just as it comes to life, it will soon disappear. This chocolate will not make it into a recipe book, or on a check. It does not exist. It is the true essence of my cuisine where sometimes a product that breaks the rules, lands on a dining table. That night, we did not have enough of them—the chocolate left and never came back. It stole the moment.

Fried bacon, grilled
squid, sautéed
cauliflower: three
stands to hold roasted
mirabelle plums
surrounded by a
mirabelle plum purée
and a colombo (mixed
spice) sauce.

DANCE FLOOR.

76

Until I was twenty-five or twenty-six, I did not know much about ingredients. My universe was limited and simple: potatoes, rice. I did not really work with ingredients such as foie gras. When I finally discovered other spheres, it was a revolution, and it has been a source of constant amazement ever since. For example, ingredients with a rubbery consistency like cuttlefish, squid, octopus. What a dance! And then there are ingredients that are a little bland, like rabbit or potato. Interest grows with the discovery of textures and the process.

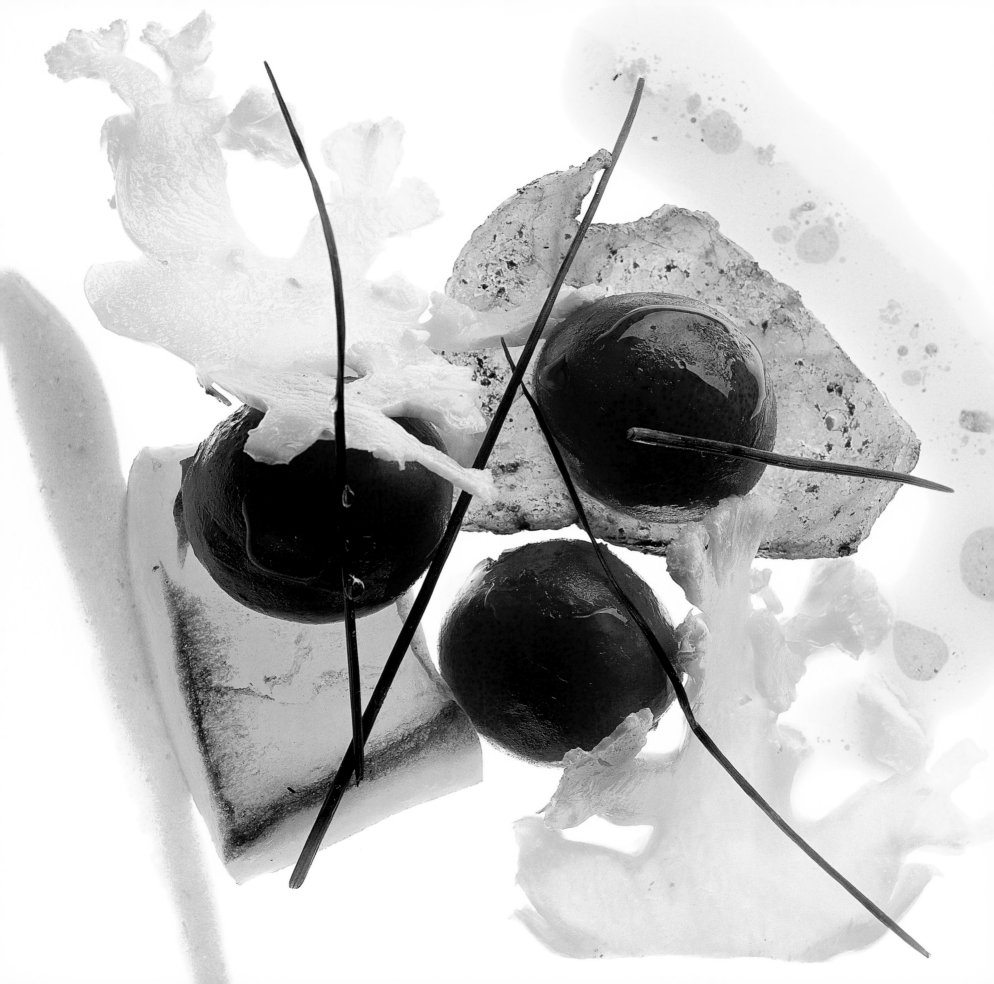

A slice of lemon
confit capped with a
square of green apple
gelée, an Italian
meringue, leaves of
lemon verbena.

THE HIDDEN FACE OF LEMON.

78

Why restrict lemon to its acidic note? For the answer we ask the citrus family. Ask why there is such a muddle about their appellations and origins. Market stalls don't give out much: maybe the category and grading, but hardly more. And yet superb lemons can be found. This one is from Menton on the Riviera. It is your entrée into a sensuous universe—the juice, zest, form, texture, and density. This fruit has lovely flavors, but above all a tender side that you don't expect from a lemon. It is here paired with an Italian meringue, but I can see it just as easily expressing itself elegantly with a warm butter cake or a vodka sorbet.

Two white chocolate
tuiles and wild
strawberries to escort
a rum parfait.

DIALOGUE.

80

My patissier, Didier Mathray, and I have had a silent dialogue for about ten years now. I throw out an idea, he catches it, develops it, deploys his technique, gives it a new twist. These lacy egg whites, toasted almonds, pistachios, fruit confits. . . . They are like the tempting cover of a book we can't wait to open. Our dialogue has started: truffle soufflé, truffles in a supple cream sauce, brittle cookies. . . . The combinations go on and on.

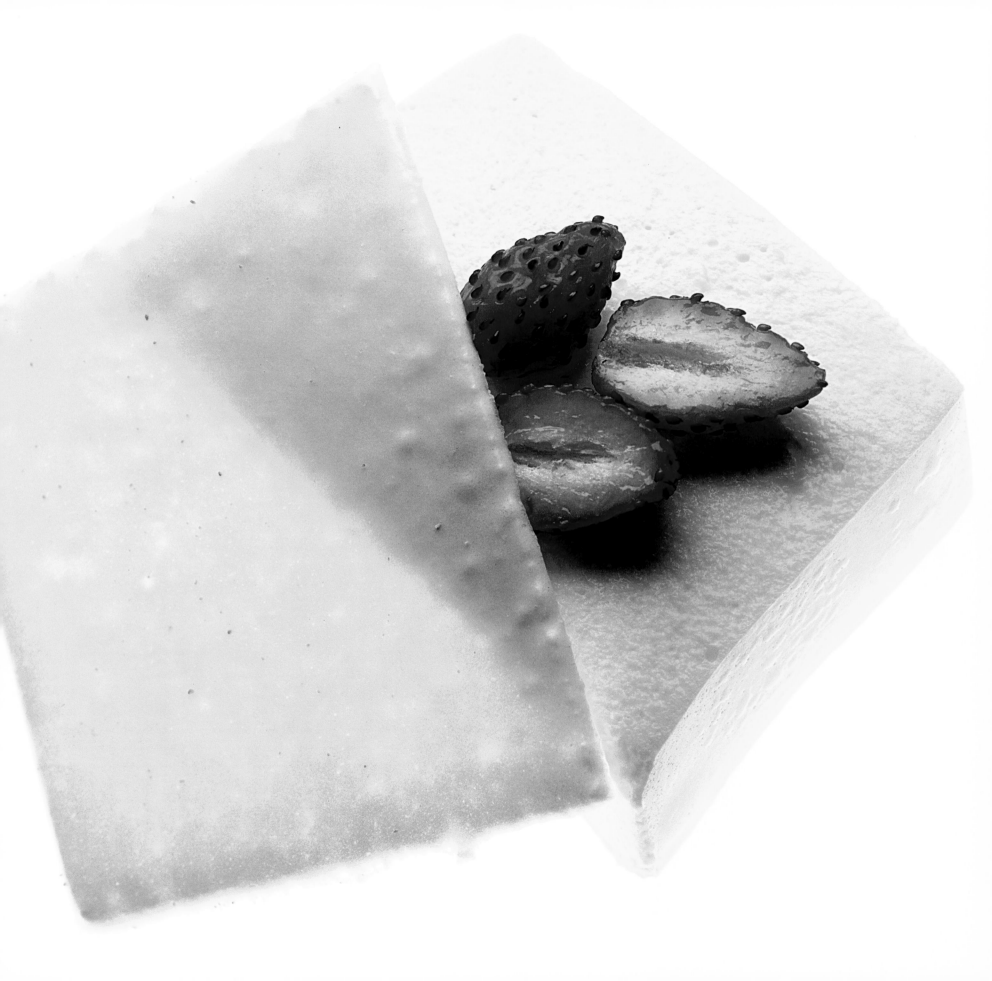

Mini sweets thinly sliced and ultra-crunchy: florentines and royal ice cream flavored with lemon and gentian.

REFLEX.

82

When I see this wafer-thin cookie, the toasted almonds, the thin shavings of caramel, my fingers find a life of their own and reach for them. Silverware is not part of the equation. Only fingers can deliver this sensuous contact, this caring respect for the ingredients, snap the cookie sheet, pinch the almonds gently, and understand that subtle music. Sometimes utensils become awkward. The natural gesture takes over, and it feels so right.

Walnuts, hazelnuts,
pistachios, and dried
fruits compose this
cake called mendiant.

HORIZON.

Just a powdered caramel, this flat dried fruitcake of walnuts, figs, hazelnuts, and raisins is lightly perfumed with whiskey. Why use this last ingredient? Simply to give the cake some vigor, to seize it, to take it elsewhere. The taste of peat intensifies the caramel note. Then this little cake can take a more ambitious road: crab, lobster, vegetables. The whiskey is like a key that opens the expanse of the horizon.

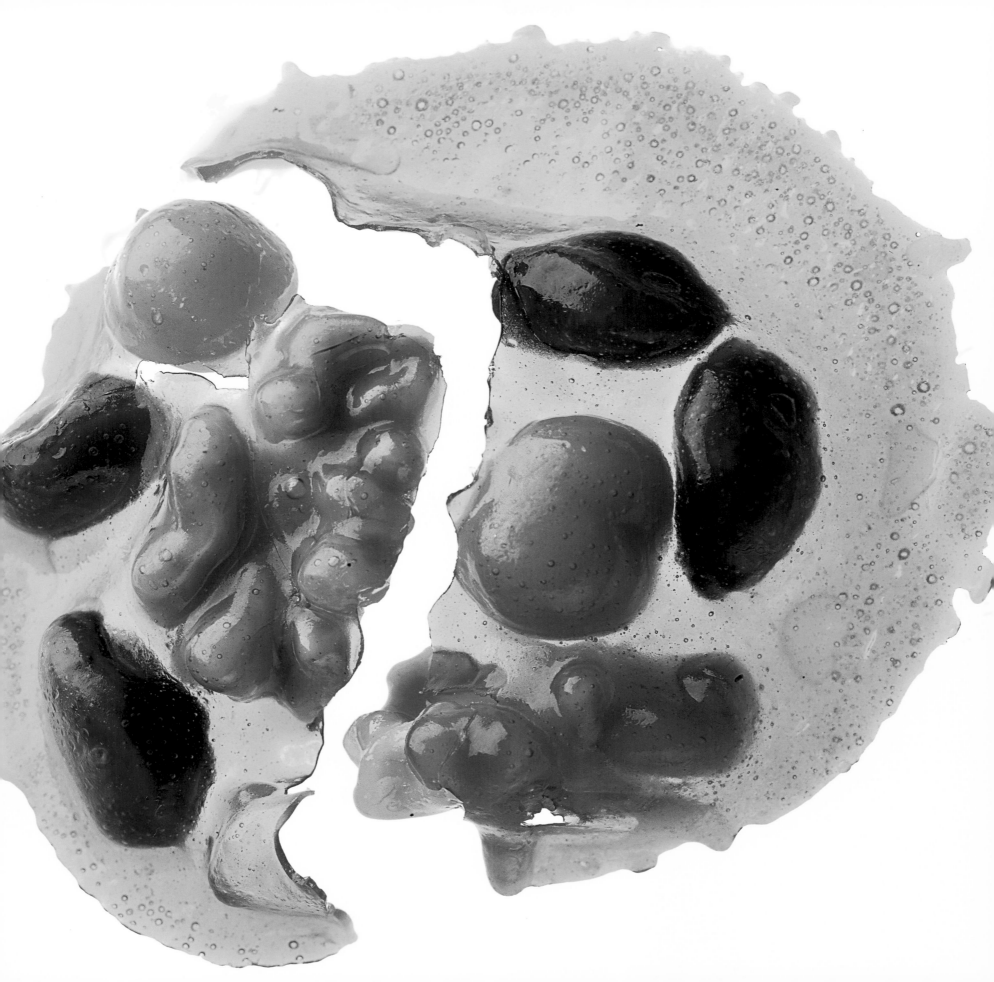

Lacy Brittany crêpes
sprinkled with brown
sugar, garnished with a
ribbon of yellow carrot
and a fan of toasted
green apple slices.

TO WAIT.

86

I don't think of myself as a creative person. I am not more clever than others, but perhaps I'm more attentive. I spend my life watching ingredients, waiting for them to surrender at the peak of their maturity and flavors. I am in tune with them. I observe. My work draws from what I have learned, what I know, and what I see. Then, I go further. At first, there is a strong feeling to create, then comes this desire to render details in all their nobility.

In a cloud of carva
(Spanish sparkling wine)
sorbet, a cluster of
Muscat grapes and
their gelée.

QUIET PLACES.

88

Sometimes, before going too far afield, you need to step back and listen to the produce. It is staring at you. Before taking out the frying pans, lighting the ovens, you should at least ask what these grapes really want. The answer is evident within a few seconds: these grapes don't want anything. No technique, no flick of the wrist. Just a quiet place to be themselves.

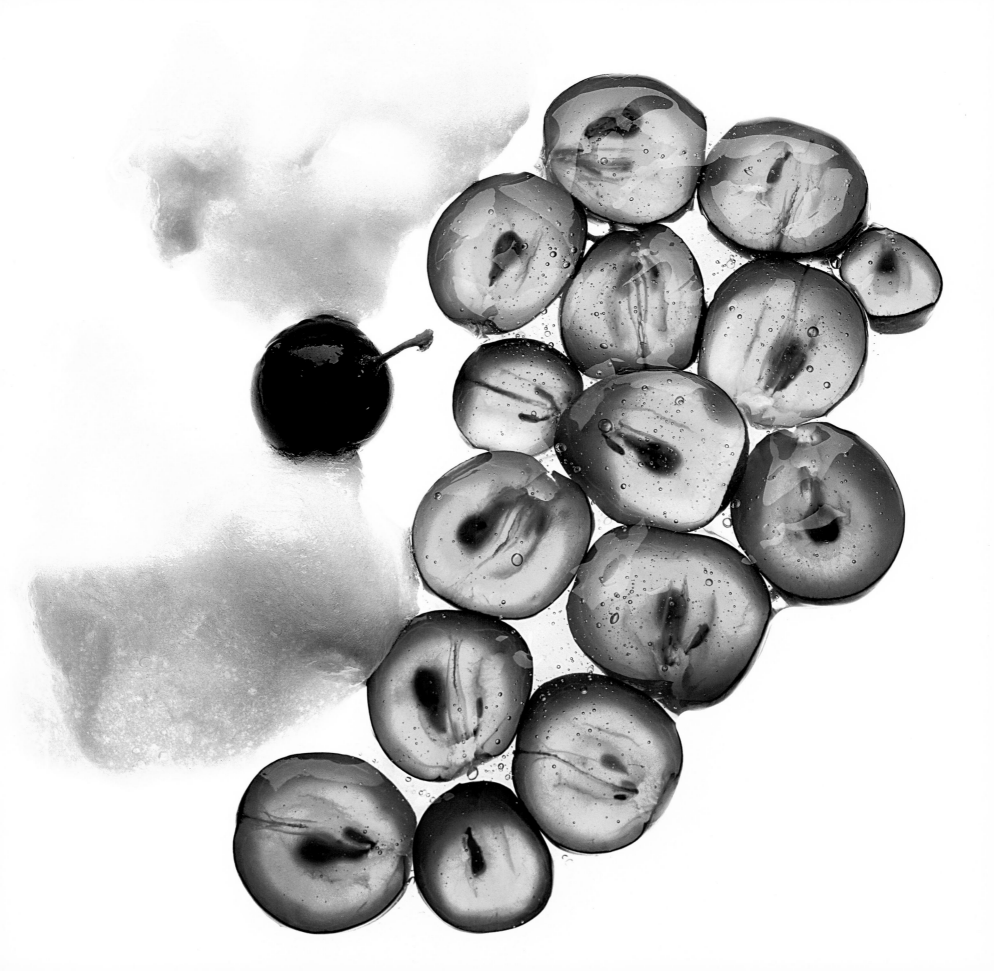

Dried and confit fruits
set in a pistachio
parfait, paired with two
wedges of limequat,
very green, and its
pistachio-green seeds.

HE WHO GOES HUNTING FINDS HIS PLACE.

90

Often there is a moment in a dish when it becomes free. Until then it quietly sticks to the plan; it doesn't step out of line, it stands obediently at attention. And then suddenly, it's off; it goes hunting. It discovers insolence. In this composition—a pistachio parfait accompanied by large toasted pecans—this instant comes with the limequat (citrus fruit between a lime and a kumquat). It's up to the diner to squeeze out a few drops—and in so doing, he takes an active role, makes the dish his own. And so the restaurant finds its calling: to create a moment that diverges from accessories like butters, flowers, and small spoons, but rather in this poetry of the instant. The simpler it is, the more it hits home: a sprinkling of salt on a truffle, a soufflé broken open, the crystalline fragmentation of puff pastry, and the few drops of lemon on this parfait.

Crackling, fruity, juicy:
one, two, three
blueberries in their
shell of crystal sugar
and egg whites.

SEEK, FIND.

92

When I started in 1977, desserts were not exactly my forte. I could only make pie crust, pastry cream. . . . It came slowly, with the help of an old hand from Chez Bernachon. One day I realized that there was a real discrepancy between my cuisine and my desserts. I wanted more dissonance, a more direct and spontaneous style. So I set out to achieve that goal. This vanilla and blueberry brochette is one of the results. I do not suscribe to any system—nor pretend to be reinventing the art of dessert-making. They are just a few little discoveries, one after another. A playful puzzle.

Dried fruits in saffron
syrup: figs, apricots,
dates, walnuts, currants,
and golden raisins.

FALSE IMMOBILITY.

94

I n cooking, appearances sometimes are deceiving. Here are dried fruits, delivered in their haphazard passive state. You may think that everything remains to be done. Wrong, everything has already been done. The date was slowly poached, then dried, the apricot marinated in a fruit and brandy syrup, the walnut slowly toasted in a pan.

Fromage blanc
ice cream and black
cherry cooked in
red wine, in between
two sheets of caramel
with cumin seeds.

LOOKING THE PART.

96

Cumin belongs to the family of debtors living under duress. It reminds you of those film actors who are typecast. You see them over and over in the roles of Prince Charming, debonair cops, or nasty aesthetes. Nobody thinks of them any other way. I hope they don't see the comparison as insulting, but cumin is the same. It's always associated with Muenster cheese, yet cumin has other arrows in its quiver. Let's see: carrots, mussels, or, as here, with a caramel and a black cherry confit. Let's go on: with foie gras cru, ham, strawberries....

Translucent slices
of pineapple in ginger
and curry syrup paired
with a coconut and
pineapple confit cake,
tied with a ribbon
of rhubarb skin.

DISCONNECT.

98

In this dessert, the pineapple appears in two guises: raw, macerated in a light syrup; then cooked as a confit. The rhubarb, a difficult ingredient, advances cautiously in this composition. Here, its skin has been blanched, then lightly caramelized, being careful to preserve its flavor. You could almost say that the rhubarb crosses the plate by accident. It is aware that the pineapple is at its own party, at the center of things, working up a sweat. As always, the rhubarb is elsewhere.

WHIP THE DISH.

100

Meringue is humble. All alone, it is basically nothing, almost heretical in its devotion to sugar, its empty crispiness. And yet people love meringue. Memory of childhood, cake of innocence, meringue finds its true dimension when it is accompanied by other ingredients—ice cream, of course (as long as it is softened enough), but also mischievous partners like this green tea powder and endive salad. They carry the dish, lift it with a refreshing solidity.

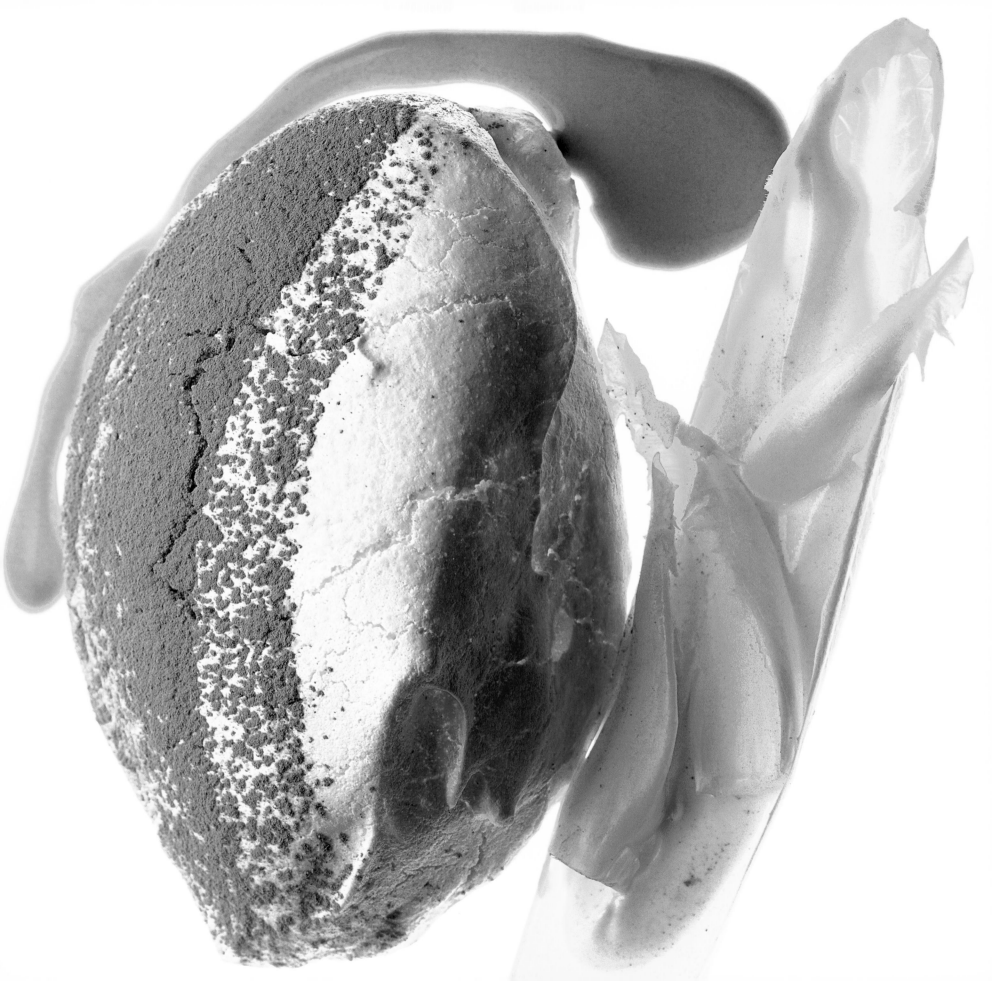

The flowers of the
sage pineapple
embrace an unctuous
blood orange
parfait with its zest
confit, escorted by a
walnut nougatine.

DAZZLING.

102

Sometimes you forget that a dish has a very short life span. It is a magical moment when it stands up, when it attains its stature: brilliant, pearly, spirited. A few minutes later, it becomes lifeless, the meat shrivels, the colors fade, and the spinach weeps. And worse than that, it becomes cold and its flavor vanishes, along with appetite.

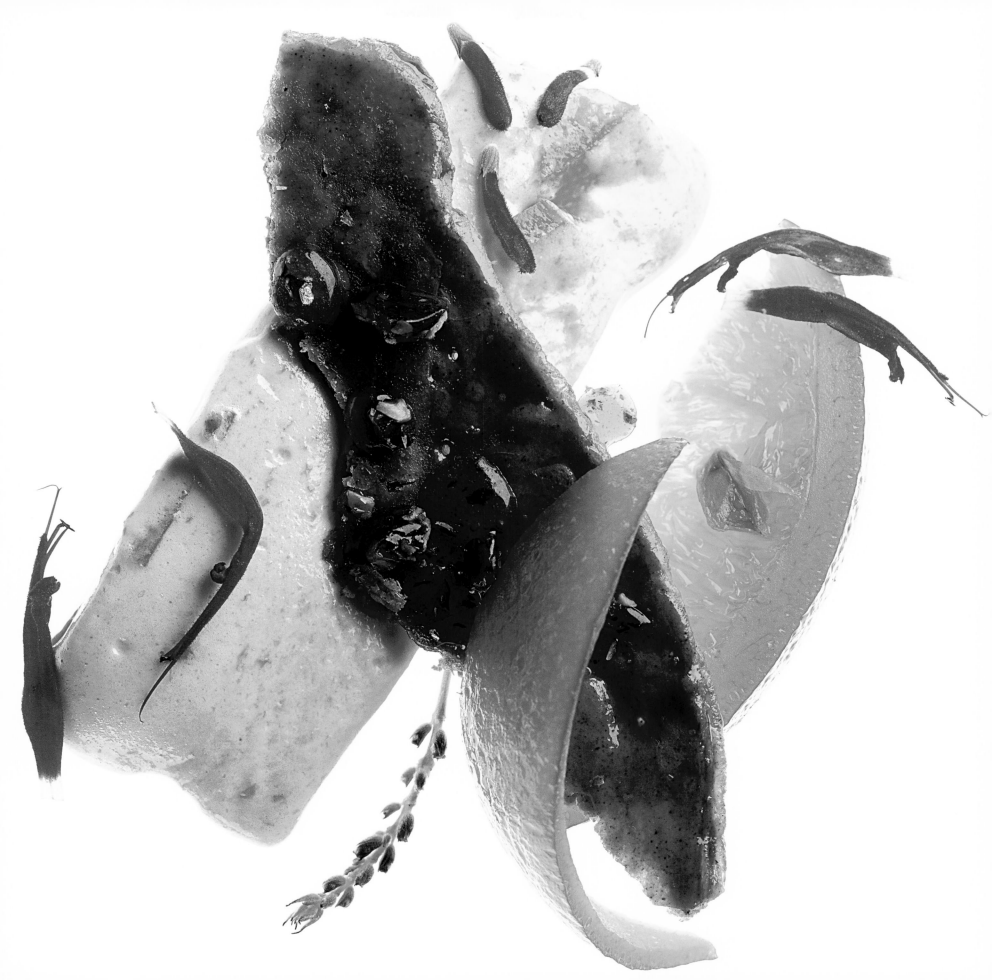

To Be Always Clear.

104

Sophistication should not muddle the interpretation of dishes. If you add flavors and textures, it's really to bring forward an idea. Here we started a dialogue. A burlat cherry, so beautiful in its character. We are also faced with a question, and at the same time the beginning of an answer. It is up to the honest quality of the ingredients to pursue the conversation. A chicken breast, some thyme, some oregano. It is about staying tangible, transparent, and accessible. If the dish doesn't speak for itself, it's a failure.

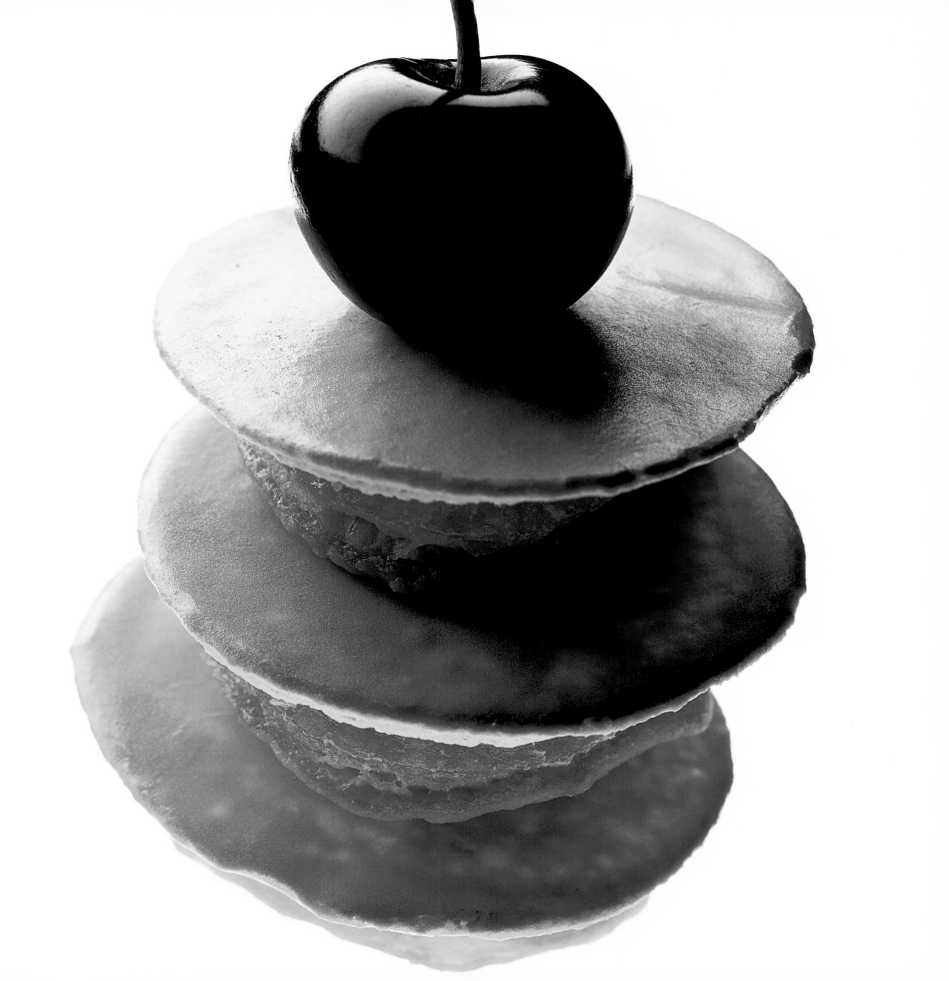

Discussion on the Cuisine of Pierre Gagnaire

By Bénédict Beaugé

108

"(Beautiful), as the fortuitous meeting on a dissection table of a sewing machine and an umbrella!"

Lautréamont, *Les Chants de Maldoror (VI.1)*

From the beginning to the end of the meal, anything seems possible. If the cook chooses to disturb our habits, remove our guidelines, all that is left is to surrender to our own pleasure—to be surprised, to explore all the potentiality of an ingredient, and to dive into the cook's imagination.

For more than twenty years, Pierre Gagnaire has not ceased to astonish us. Even through adversity, his imagination never diminishes and his cooking—which from the beginning has baffled more than one—turns plagiarism into failures. His cuisine today is certainly different from when he started, but what has not changed is his unbelievable associations of flavors and textures and the perpetual transgressions—the ocean meeting the earth or vice and versa, sugar mixing with salt. Over the years, the public's taste has changed and the chef's mastery has been brought to new heights. Today, his instinct and intuition is still at center stage, but it no longer overshadows his other talents. After the exaltations and reversals of fortune, serenity has settled in and the cuisine evokes a feeling of expression and fluidity. Although Gagnaire's cooking still has a very baroque quality to it, at the same time it has entered a classical period. This *cuisine immediate* (also the title of his first book, published fifteen years ago) tends to blur the borders. Gone are the dividers between the dessert course and the rest of the meal, especially since cheese is now also prepared. Like any other course, if only a little sweeter, the dessert follows the same principles.

The Original Verb

Pierre Gagnaire likes to say that the words are what lead him to open the doors of the cuisine he is practicing today. Poetic words like those used by Alain Chapel in the titles of Gagnaire's dishes; defining words like those by Jean-François Albert, a friend and journalist; and powerful words that express a diner's emotions. Gagnaire is not sure why he became a chef. As the oldest son, he seemed destined to take over the family restaurant that his father opened after the war, Le Clos Fleuri. But during his apprenticing years, Pierre Gagnaire was bored around the pots and pans. Eventually, at the helm of the family restaurant, his timid experiments suddenly found an echo and stirred some emotion in critics. Their words were the testimony, which became a revelation, a trigger. They recognized that the cuisine he had seen prepared by others, at best with conscientiousness but still with a lack of enthusiasm, could become something other than the routine. It could be creative and, at the same time, a tool of seduction. He made his decision and said goodbye to Le Clos Fleuri, where he had felt restricted. He then opened La Richelandiére in Saint-Etienne in an old photographer's studio that

had been converted into a cafeteria and in doing so, Gagnaire promised himself to banish the routine from the kitchen, the routine that had tempered the aspirations of so many chefs before him.

This rupture is reminiscent of Kandinsky, when the artist abandoned figurative painting and embraced the abstract. Just as Kandinsky, who applied lines and spots of color with a knife on blank canvases "to make them sing with as much intensity as possible," the chef suddenly walked away from the basics of his academic training. He began to focus on the game of tension among the different elements on the plate, as well as their relationships, regardless of their origins. We are in 1981: the pioneers of the Nouvelle Cuisine—Michel Guérard, the Troisgros brothers, Jean and Pierre, and Alain Chapel—had mapped out the road by revolutionizing French cooking in the 1960s. Gagnaire had high esteem for these four chefs, but his vision was to be more radical. These chefs found their inspirations in traditional, regional, or bourgeois cooking and incorporated it into Nouvelle Cuisine. They simplified it, making it more transparent. Gagnaire's approach was to trust his intuition fully—nothing else matters. His passion for contrasts, departures, and, consequently, large expanses of calm to set off the meal, seem to regulate everything (a deceitful appearance, as we will see later). However, how do you convey to others what the ingredients themselves seem to have dictated? How do you make understood such oppositions and harmonies never seen before, at least never attempted?

More than any of our other senses, taste requires a language. That is just the way it is. Because of its association with original sin, taste has been ostracized, while sight or sound are considered the more noble senses. As a result, taste suffers from a limited vocabulary. To make it "speak" we must then use periphrases or metaphors. Words hold an appetizing and digestive function, and Gagnaire understood this. He experienced it. And, if he acknowledges that he is not a gourmand, he certainty has a gluttony for words. First, words stir a curiosity; later they translate the emotion. On the menu, they allow the diner to get acquainted with the unusual alliances; they make him question those unexpected collisions of textures and flavors. Then the words are there to help decipher his own emotions, transcribe them—and he may eventually return them to the chef as a gift. But the most important part of this gift is that the emotions are passed on—the words remain like sea foam, the trace of the emotion.

The Poetry of Atlases and Dictionaries

Of the four fundamental principles in cooking—select, cook, season, and assemble—the first and the last, at first glance, seem to hold the most important role for Pierre Gagnaire. Even on the restaurant menu, the sensual emphasis in the description of the ingredients, their variety or origin, jumps at you. Kandinsky granted symbolic strengths to colors and therefore great importance to their selection; his

painting is a game of tension and rhythm in between the colorful lines and the dots, and the richness of this expression is directly linked to the palette. The cook, like the painter, tries to diversify his art, explore all its nuances, and for Gagnaire the palette is the multiplicity of his ingredients. These ingredients can "speak;" we just need to listen. What they symbolize can be found in what I'll call the poetry of atlases and dictionaries. Of course, above all, the ingredients are selected for their own qualities but also for their power to trigger the chef's imagination (and ours as well). The small red peppers or pimentos do not simply come from the Basque region of Spain, but from Guernica (menu 1) the salt sprinkled in the truffle soufflé (menu 2) is from the Himalayas, evoking qualities of purity and frozen solitude. . . .

If you subscribe to this idea, everything falls into place—noble or humble ingredients, local or exotic, can then enter the dance and reveal themselves. These ingredients may come through a spice merchant from Rajasthan, a chance encounter with a Catalan fisherman, or possibly a *charcutier* from Corsica, but they all eventually will rally into the chef's repertoire. A new product for Pierre Gagnaire is a bait, a challenge to find the right partners, no matter what they are, and be able to speak to all of them. In that manner, the white lard from Collonata, just warmed under the broiler, is laid over a mullet or bass (menu 3) like a transparent veil, hiding a few capers brined in a salt from Pantelleria. This exceptional lard is traditionally served just as you would butter on a slice of bread. Here it takes on the role of a

compound butter in classical cooking. It also adds a new dimension to the dish—the improbable meeting of a fish with an earthy, almost peasant taste (even if today this fine lard is considered a gourmet item), not to mention the exceptional qualities that made the chef stop, take notice, draw him in—the supple but resilient texture and the aromas acquired during a long maturation in a marble sarcophagus. When it comes to lard, we are essentially talking about a condiment. The search for its refinement is easier, or at least a very different exercise, than working with fish, shellfish, meats, poultry, vegetables, and fruits, which are the foundation of cooking.

When Gagnaire settled in Saint-Etienne, he was faced with the same problem every young chef encounters—lack of funds. Although his intuition guided him toward a breakaway cuisine, he didn't have access to the noble ingredients needed. It was impossible for him to develop a cuisine of produce like the one Chapel created. Gagnaire chose to direct his culinary skills to the forefront rather than letting them disappear behind the ingredients. In following this path, he was distancing himself from the chefs of the previous generation, the pioneers of Nouvelle Cuisine, who had taken the opposite road to free themselves from old habits and constraints.

Eventually, with his reputation and popularity growing, Gagnaire was able to afford nobler ingredients. He would seek them out with abandon but without changing his approach to the craft, and the realm of possibilities simply opened. Cooking remains for Gagnaire the art of establishing

relationships between flavors, textures, and aromas and making use of all available resources. What has changed is that some foods are used less frequently. For a demanding cook, some products are difficult to secure with any regularity, and insufficient quantity. For example, when the tomato is in season, you can find it everywhere but we know how difficult it is to find one that tastes like a true tomato. This simple fact has strengthened Gagnaire's culinary conviction that to serve popular ingredients in a luxurious establishment you can't just let them express their simple truth. They must be enhanced by using them with something else, entering them into in a web of relationships in that game of tension that constitutes the essence of a dish. Thus, some of the chef's most successful creations were conceived from simple ingredients such as pork (menu 4), bluefish, sardines, anchovies, some shellfish, and forgotten fish such as skate.

Rhythm and Combinations: A Baroque Taste

What I call the Baroque Taste applies to all eras and disciplines, including cooking. As soon as you encourage a sense of energetic tension, motion, and rhyme, you find yourself slipping into a Baroque universe, and there Pierre Gagnaire finds his place. Very few recent cooking styles have put forward the desire to surprise. In Gagnaire's restaurant you'll often be served a dish slightly different from what you thought you had ordered. Based on the dish preceding or following, the chef, at the last minute,

may decide to add or remove an element, just to make the dialogue of the meal more coherent.

Pierre Gagnaire likes to say that one has to listen—to the ingredients and the cooking tools, and constantly stay in tune with what they tell you. This approach allows him to find a theme among these associations, which so often surprises us. Certainly one of the reasons he was able to leave Clos Fleuri and to launch his new cuisine is the conviction that the ingredients could speak in a new way, like Kandinsky's break from figurative painting. To celebrate these alliances, all that was necessary to do was to understand what the ingredients were capable to offer or, on the other hand, what they were asking for. All great chefs share this ability to listen, but Pierre Gagnaire stands out in this regard with his lack of preconceived ideas and his ability to keep an open mind. He knew that to escape the looming boredom that had overcome so many others he needed to greatly expand the realm of possibilities and abandon all conventions and restrictions—this is what is needed to keep his interest in cooking alive. This radical break that he introduced in cooking is probably what allowed him to develop his ear.

More than any other chef, Gagnaire needs to find the right harmony. The many ingredients on the plate bring along a moment of uncertainty— which one will the diner's fork reach to first? And within this harmonious assemble, Gagnaire is also aware of the individual components. Again, we are reminded of Kandinsky and his awareness of the musicality of colors. In his paintings, you may see a keystroke that seems to take on many

shapes, but along with his use of colors a web of relationships is created. Gagnaire has a musical ear, so it is not surprising that his universe of taste is also that of listening.

Gagnaire's talent to listen has allowed him to create dishes never seen before. Who before him has dared to combine bass with sweetbreads and foie gras, or bluefish, langoustines, and ketchup? Who has dared to season grilled scallops with licorice, or serve a pear dessert with lamb's lettuce? It was an overwhelming surprise and twenty years later it still is. Refusing to stay still, Gagnaire has laid a path for himself to continuously go further and share with us his new discoveries. Even in a luxurious restaurant the palette of ingredients, so to speak, is limited. Not only, as we have seen, does Gagnaire constantly expend the palette but he gives more volume to it, constantly reinventing it, playing with the flavors and textures, looking to conquer unexplored territories of taste.

Happy surprises for the ones who at the beginning recognized his talent, but also for those who rallied later. In the chocolate course, the Grand Dessert, February 2003 (menu 5), which I describe later, each element of this classic could receive the precise date of its creation. The diner delves into the dessert with the marvel of a child unwrapping a present. This is a friendly gesture, the chef's desire to share, which is a side of Gagnaire's generous spirit and a quality we will discuss further.

The surprise of the unexpected alliance intensifies with the architecture of the plate. In the introduction to *La Cuisine Immediate* Jean-François Albert noted the chef's fondness for verticality.

If his tendency to stack up has been tempered somewhat to allow for more horizontal landscapes, his interest in layering is still evident. A gelée, sweet or savory, coats a cream or a mousse; a tuile hides part of the plate (a baroque staging) that does not reveal itself at first glance. On the "End of Winter 2003" (menu 6) sweetbreads are associated, in a playful wink to classical cuisine, with crayfish. However, instead of transforming the crustacean into a trophy, claws out like headlights, here everything is hidden underneath a layer of crispy dough, covered with spinach leaves, sautéed in butter, and assembled like scales. Nothing could be more discreet than this flat green disk at the bottom of a deep bowl, and nothing is more nimble—unless the diner deconstructs the dish, his or her fork plunging randomly into it. Each bite brings with it different textures and flavors; nothing tells us whether it will be a crayfish or a morsel of sweetbread. Gagnaire's afinity for layering may explain why he loves pâtés and stuffings. In his stuffed quail, for example, game meat and offal may be part of a very sophisticated recipe. Or foie gras and lamb's liver, two similar ingredients that blend easily but at the same time give each an unfamiliar note, a transmutation of flavors. The foie gras brings its creaminess to the lamb's liver while the distinct flavors of the later gives a long finish on the palate to the foie gras. The stuffed quail is garnished with a date, offering another surprise. The bite encounters resistance— not a pit, but a hazelnut and its toasted spirit.

The delight that comes from these surprises contributes to the childlike amazement I mentioned

earlier: the cuisine of Pierre Gagnaire is always a discovery of the unknown, but at the same time it asserts itself with common sense. There is a feeling of "of course, obviously . . ." in his dishes. Although no one might have thought about it before, once tasted these new associations linger in the memory because they are so natural, so obvious. Yet really nothing is less natural, hence the initial surprise followed by the pleasure of discovering something new, something unknown.

The arrival of new suppliers has opened up new frontiers for Pierre Gagnaire's cuisine. The inspiration for the "Catalan Landscape"(menu 7), came out of a meeting with some Catalan fishermen from Palamos. The "dish" (it is very difficult to use traditional terminology with Gagnaire's cooking) is composed of four elements illustrating the different tastes of the region. Aside from the fact that each component is delicious by itself, the strength of this "Catalan Landscape" comes from parts being served together rather than in courses, creating a collision of unusual flavors that make sense together. The different shellfish, cooked separately, are served together in a deep plate. On the side, there's creamy salted cod with *espardeignes*, a crisp, grilled *fressure* (liver and heart) of lamb, and, finally, a bowl *fideùa*. These exotic names themselves make the dish intriguing. Most locals, French or Catalan, are not familiar with them. What are the *esparteignes, pistres, casserons*? And *fideùa*? They are various types of shellfish—little squids, calamari, cuttlefish—that the Catalans are quite fond of—and

the *fideùa*, it is a type of rabbit paella made with vermicelli (*fideùs* in Catalan) instead of rice. But this is not what's important—the words are here to make us dream; the reality of the dish is somewhere else. It is in the playfulness of the textures, the firm and tender shellfish, the lamb and rabbit livers, the powerful flavors of the offal facing the squid (an unusual encounter, yet very convincing), the balance between salty and sweet, soft and crisp. Suddenly, all those sensations interact, creating layers and conjuring up an image of Catalonia very real and recognizable.

These dishes can spring to life, as we have seen, from an encounter such as the fisherman of Palamos. They may also be sparked by a memory, an image, as with "Mediterranean" (menu 8) "Deep Sea" (menu 9), or an ingredient too humble to explore but with strong evocative powers, such as a red pepper from "The Orient" (menu 10). The inspirtaion for this dish may have come from memory of a *chachouka* (a sort of ratatouille made with tomatoes and red peppers) or a fragrant tomato from the garden. Whatever it was, the ideas seemed to expand on the plate, changing shape in concentric ripples. Other vegetables came along with the pine nuts and the pomegranate seeds, the sweet and sour carrots glazed with strawberry tree honey and argan oil, a Napoleon of squab layered like a *pastis* (a Morocan flaky pie) with almonds and toasted hazelnut cream. This entrée is characteristic of Pierre Gagnaire's sensuous universe. First, a great diversity of textures and consistency; then a spice, present yet discrete—the saffron that permeates the compote of red pepper—almost like

a memory, an evocation. A full palette of sweet/sour or sour/sweet flavors that also emphasizes the balance between sweet and salty is in every part of the dish. Finally, the crowning moment—the introduction of the squab *pastis* as a condiment. In terms of imagination, this association is a success, evocative of the Orient. However, each dish's balance of flavors are just as successful—the suave and sweet accents are ever present, yet none dominates. A similar idea was explored in a meal dedicated to Tunisian women. Each element carried at least one sweet accent from fresh or dried fruit or honey, and each featured a different spice. Menus created for special occasions or events or to honor distinguished people usually set a framework for Gagnaire's imagination but are similar in style to what you'll find on his restaurant menus.

After leaving Saint-Etienne, which we know was a difficult time, Pierre Gagnaire moved to Paris, struggling to reorganize his ideas and start over. This misfortune had taken its toll. At the suggestion of his wife, Chantal, he began to organize his menus by ingredient, using each one as an axis. Again, although it may seem simple, he was the first to apply this idea, and was to be a saving grace. He had needed to ground his cuisine again. A cuisine that, as the chef says, "can grow from sphere to sphere, layer to layer," needed a center of gravity around which everything could come together. The words on the menu would act as reminders.

The cuisine of Pierre Gagnaire has gone through what I'd call lateral periods and others more vertical. Today, his cuisine appears more horizontal, but we are not talking here

of the "indirect lighting" Jean-François Abert discussed in Gagnaire's first book. In focusing his attention on the ingredients, the chef discovered something that he had either forgotten or neglected until then, something that none before him had put into practice.

Although, we had seen theme menus before, the concept of theme dishes was something completely new. That is, if we can still use the word "dishes" to describe these "New Culinary Entities"—a "full course" would be more appropriate, as we have seen in the "Catalan Landscape" and "The Orient." The same creative discourse set around an image can apply to both a single ingredient or a coalition of them. Gagnaire paints dreamy portraits of cèpes, veal (menu 11), pork or langoustines (menu 12). The latter, langoustines from Brittany, are presented four ways: sautéed, as a mousseline, grilled, and as a tartare, and with a different seasoning and garnish for each preparation. Here the cook introduces a new challenge to the diner: How should this "New Culinary Entity" be sampled? Where do you start? In this instance, Gagnaire explores the proposition made by Raymond Queneau in *Cent Mille Milliards de Poemes*—a potential cuisine just as the writer had imagined a potential literature. A cuisine made to play with, to broaden the elements of taste, and in the end give the diner *"cent mille millards"* (one hundred thousand billion) sensuous experiences, the exact opposite of culinary integrity.

If the diner isn't paying attention, he might think that this cuisine is built by juxtaposition, just

like *mezze*. But that would only be the case of the plagiarists for whom only the cruel words of a critic apply: "an orgy on the plate." For Gagnaire, his model may be, whether conscious or not, the classic *Grand Service à la Francaise* from many generations ago. Back then, the maître d' was in charge of orchestrating the menus and conceiving the arrangement and order of the dishes for each specific course. Each course included one or more centerpieces surrounded by many side dishes, which were positioned following very precise rules and hierarchy. The talent of the maître d', just as that of Gagnaire and his cuisine, was to guide the diner through the experience, the pleasures of discovery. This is an exercise in generosity, which allows the diner to experience many different tastes according to personal preferences.

In the end, the cooking of Pierre Gagnaire is less complicated than it seems, at least in concept, which is what draws the attention of the critics more than anything else. As a rule, Gagnaire starts with two or three ingredients, looking at each individual expression and also unity of taste. Once this is done, there is the addition of other elements that share some affinity. The dish then takes hold—in the words of Gagnaire "we play, we juggle, and suddenly you can say it's ready." But it does not happen all at once, and this is why the dishes on the set menus are always less complex than those à la carte. The scale changes, or, more precisely the temporal system—on the set menu the various elements weave themselves in time, while on the à la carte they do so in space.

On the restaurant's website, you can find clusters of molecules that can be used as metaphors for Gagnaire's cooking. These atoms, the "elements of taste" can link with each other and form molecules; other molecules then interact to create new connections. The resulting new entities will therefore be more coherent, as they contain more connections. This metaphor for Gagnaire's cooking could go even further—it illustrates the capability of his cuisine to evolve, to transform itself. His passion for the instant, the immediate, is the counterpart for the instability of the atoms. Just as this instability allows the atoms to connect with primitive structures or to escape and be replaced by others, a dish may have one of its satellites and transform itself, disappear, or tag along. Gagnaire insists on this notion of immediacy. Hence, the importance of the chef's physical presence with his kitchen staff—that is Gagnaire's personal investment.

One of Gagnaire's favorite words is "peaceful." He often talks about his "intention to slow down the game, to bring serenity to the plates." Any designer, painter, architect, or musician, moved as much as he is by rhythm, knows the necessity of the blank pages, the quiet moments that are the soul of creativity, or at least an indispensable element. Although it may seem obvious that without downtime there would not be fresh moments, this notion is often forgotten in cooking. Usually the assault of flavors comes fast and furious, allowing little time for the palate to rest, and saturation comes quickly. In this respect, Gagnaire may have an Asian sensibility, perhaps

Chinese, where white, neutral, and emptiness are an intricate part of the cuisine, and where painting and philosophy also come into play. And perhaps a Japanese sensibility as well, although the Chinese influence appears to be stronger. If his creations are reminiscent of the Grand Service Français, they also share some similarities with a Chinese banquet, at which gustatory pauses play a fundamental role. For example, in "The Flavors of the End of Winter" (menu 14) a quenelle of Arctic trout mousseline is accompanied by a fennel broth, which is served in a goblet, but still part of the main dish, with thin slices of crunchy raw vegetables. Then, facing a terrine of foie gras layered with coppa, *pastis* of squab and black trumpet mushrooms and a crab "cake" with green mango and olive oil ice cream. This composition evokes cool streams (the fennel imparts an aquatic sensation, even though it is not a water vegetable) and gives off a feeling of relaxation, a feeling often associated with the soft sweet flavors of a mousseline or a *royale* (savory custard). In keeping with this idea, in the langoustine course we saw earlier the mousseline was given a soothing quality with the addition of a frosty butter lightly seasoned with lemongrass.

The à la carte dishes are designed to offer choices to the diner. Following Gagnaire's suggestions, the diner builds his own dish, either introducing pauses at will or organizing the degustation in crescendo or diminuendo. In contrast, the set menu offers a sense of rhythm— the involvement of the diner diminishes and the dishes are less complex, following the logic of the chef. In both cases, with only few variations, the balance of subtle and strong moments is ever present. In most restaurants, the difference between the à la carte and set menus has to do mostly with portion sizes. "Menus degustation," or tasting menus, (menu 15) are mere samplers, a little bit of everything. Not Chez Gagnaire, even when some dishes seem to come from the same source. Each à la carte and set menu, subscribes to its own logic and will not tell the same story. The menu takes us through a linear story chosen by the cook. The à la carte proposes a very different structure, which is more compact, almost erect, with few connections or anchors. Gagnaire does, though, reserve the right to intervene in order to give more coherence to the meal as he sees fit. But either way, some ambiguity remains. Pierre Gagnaire sees this as a never ending culinary game. If the instant is what keeps cooking alive for Gagnaire, his patrons would do well to embrace the same principle, and in doing so share intimacy with the chef.

To Cook and to Season: The Rigors and Demands

As we have seen, cooking is more a matter of evolution then essence for Gagnaire—the world's most beautiful ingredient, if not helped along, is nothing, or at least not very much. This remains true today despite the range of his palette. To create these alliances, he has had to bring each "element" to a point of, what we might call, unnatural expression. Hence this patient listening, this long examination to be able to understand each

ingredient, entering into their most intimate places to figure out how to handle them. Numerous examples of this quest can be seen in the pictures and their commentaries in the pages of this book. These interpretations highlight the obvious, but often overlooked role of techniques, training, and, surprisingly, the influence of the tradition on his cuisine.

Engrossed in the pleasure of expression, in the early 1980s, Gagnaire did not concern himself too much with techniques; he employed the minimum required to transcend the humble ingredients available to him. His skills were acquired in some of the best French kitchens during his apprenticeship. However, the late 1960s and 1970s were years of rebellion against authority and constraints. At this time, the pioneers of Nouvelle Cuisine were letting go of the use of roux and heavy stocks. Over time the range of Gagnaire's ingredients expanded, some of their qualities changed (even if he remains faithful today to those he used at the beginning), and his staff grew. Managing a crew of fifteen is much different than managing a crew of three. Suddenly, Gagnaire found himself in a position of delegating, dividing the work, distributing the tasks, and, consequently defining them with precision. As a result, techniques were to became important to Gagnaire. He was to see that these techniques would allow him to push the ingredients further, to make them speak in the right tone—by embracing the system, he would gain freedom and be open to more possibilities.

This is to say that Gagnaire has become

obsessed with techniques. He still is a designer of the fragile, the fugitive. But in agreeing to adhere to some conformity, he has found that he can create more emotion-filled moments, and, possibly, enable them to be more understood. This has given him the ability to remain creative and spontaneous. Each "unit of taste," as I have named these primary harmonies, which by their melding constitute the dishes, is the result of various mutations necessitating very different techniques. Gagnaire's cuisine is not an exercise of assembling several ingredients and erasing their personality by using the same process or seasonings. On the contrary, he tries to heighten each of them, highlighting their qualities and differences individually and together. Technique has become a means of allowing these types of "elective affinities" to come together.

If Gagnaire's apprenticing years were colored by boredom, he has very found memories of Jean Vignard, the first chef he worked with. Already up in years by the time Gagnaire started to work with him, the dignified Vignard had been the chef at the Court of Sweden and was now, for family reasons, running the kitchen of Chez Juliette, a small restaurant in Lyons. Alain Chapel, who apprenticed with him as well, remained a friend and visited him often. Vignard's style of cooking has most likely had a great influence on the acclaimed chef. His recipes came from the simple bourgeois cuisine of Lyons and were very straightforward— pâté in pastry, chicken in vinegar, lamb loin, thinly sliced potatoes in Calvados, for example. Gagnaire was struck by the chef's intimate knowledge of

both his ingredients and his kitchen tools, and especially the way he would load the stove with coal to create heat, and maintain different temperatures to accommodate all types of preparations. The sole, the lamb, and so forth, all found their place on the cooking surface, and were moved around when needed to ensure perfect doneness. In the case of lamb chops, watching their ballet to the end and a quick deglazing with a couple of drops of water just before they were carried into the dining room, still sizzling, fascinated the young apprentice. The modesty of the chef, his dignity, respect for himself and others, along with respect for his work, seem to have deeply influenced Gagnaire. These days Gagnaire's cooking is millions of light years away from that of his old master, but he still feels close to him and his principles: of staying engaged, doing one's best, and doing well.

At the risk of causing the traditionalists to scream (and they have done so more then once), I'll say that even though Gagnaire's cuisine might seem revolutionary, Gagnaire is still mindful of the guidelines of traditional cuisine. To allow the ingredients to interact, to create "gustatory arches" (just we have electric arches) between them, the chef handles them, works with them. He used to use the words "to prepare" (Jean-François Albert noted the similarity of intention with John Cage's "prepared piano"); today he would willingly say he "coddles" his ingredients, and he does so within the boundaries of this traditional cuisine. However, he introduces tradition to a few innovations of his technique. But the traditional cooking methods that have been around for more

than three centuries—the sauces, the process that dissociates then reunites following fundamental principles, allow him to follow his emotional quest. Pierre Gagnaire is mindful of but not devoted to the tradition. Tradition remains alive, but Gagnaire does not hesitate to revisit it with the help of his contemporary techniques, which include science, as we will see later. Above all, he does not pull back in front of the transpositions. For example, a vegetable may be treated as a meat (a tender piece of roasted côte de boeuf is now faced with black radishes "braised like a daube"), or transformed into a sorbet and served with a fish, just like the red beet with a bass "Jodhpur" (menu 16). It may also be slipped into a dessert, such as an endive in the bitter soufflé. Just as he decided to forgo all academic reference in his use of ingredients, he did the same with techniques, looking into his repertoire for solutions making use of intuition, letting go of preconceived ideas. Gagnaire knows when to respect the time-tested methods while at the same time questions them. He underscores this point when discussing the techniques of other countries: "One must follow, understand the basic alphabet. Then it's okay to deviate." His seductive game with tradition has become part of his freedom. He leads, but knowing the boundaries has allowed him to change the course.

On the eve of the year 2000, the newspaper *Liberation* asked Hervé This, a chemist and a master in molecular gastronomy, to create with several people including Pierre Gagnaire, a "science and cuisine" menu. Chantal Gagnaire, fully understanding the threat of boredom in the kitchen,

immediately understood the importance of this undertaking. Since this collaborating, the two have become almost inseparable. They have decided to work together on a regular basis: the scientist envisions the beginning of a trail, and the cook then explores the possibilities and tries to translate these possibilities into recipes. Several of these experiments have met with success and may appear on the á la carte menu in one guise or another, perhaps a new cooking method for beef, egg "parfait," or various chantilly—of chocolate, foie gras, or compound butters, such as the one served with the sole (menu 17), "End of Winter 2003," or scallops "Faraday." Here, the recipes are not as important as their attitude toward daily routine. What blind experimentation, after many trials could produce, can now be clearly imagined through "molecular gastronomy." Understanding the chemistry involved in cooking opens up realms of possibilities and creates more leeway, two of Gagnaire's obsessions. Using this science, aromas become less diluted, textures are new or more defined and, suddenly, the cook's palette both expands and becomes more precise. In Gagnaire's steady quest for this "gustatory arch," the interest is compelling.

The "Embodied Verb"

To witness Pierre Gagnaire in his kitchen is a unique moment. Unlike any other chef, his search for the immediacy of emotion places him at the center of the action. Unlike other chefs who rarely are even present in their kitchens, Gagnaire supervises the consistency of the plates on their way to the dining room. He is there, to be sure, but he seems to be everywhere at the same time. It is as if he has a hundred telescopic eyes—or one pair with multiple facets like insects—allowing him to see behind his back. He can follow at once what is happening in each pan, each pot and, if a something doesn't look right or an ingredient is mishandled, he is there lending a hand. And he expresses his displeasure without screaming or unnecessary discipline. As he has told me, "If I need to be in the kitchen it is for the physical battle with the element. It is a physical need for me." He is like an invested conductor who directs by sight and gesture, intensely looking for the right note, the desired effect from each musical piece. And, like the conductor expending so much emotional and physical energy, the "concert" leaves him empty, which has lead Gagnaire to develop a special interest in sport and physical health.

This battle with the elements may be what enables him to put his cuisine into words—contrary to others, he truly understands what the words mean. It's fascinating to watch Pierre Gagnaire write out a new menu, and just as fascinating to watch him relay it to his brigade. If we were not familiar with the other side of his work, this game of writing could be perceived as an intellectual contemplation or some easy lyricism. But, cooking, as Gagnaire understands it has became a revelation through words, and words are what are used to allow others to understand the food before it is put through the

fire or the fork. He may go through pages and pages of his notebooks before finding the right term and be able to articulate his new dishes to his attentive team. Armed with only these articulations, the cooks will go back to their stoves to interpret his words with only a few rehearsals.

This approach is possible because of the loyalty that ties Pierre Gagnaire with the people who work for him. Many have been with him for a long time, some of them from the beginning such as: Michel Nave, his chef, who has participated in all of the adventures, for better or for worse. The same goes for Claude Dupont, the first maitre d', in charge of service, along with his wife, Veronique, overseeing the administrative offices. And Didier Mathray, the pastry chef, who also was part of the team in Saint-Etienne, as was "Bob" Chiter, in charge of kitchen equipment. Others have arrived more recently but also have become members of the circle: Natalie Robert, pastry chef, Thierry Mechinaud, the second in the kitchen, Raphael Huet, chief sommelier, Roger Parmentier, the second maître d', to name a few. Working with these people may have strengthened Gargaire's natural inclination toward commitment. He knows how valuable loyal relationships with his staff, suppliers, and friends are. Sometimes the lines become blurred—he goes hiking with Claude in the desert, suppliers become friends, friends work for him. It was the same, for example, with the artists and creators who participated in the beautiful and sad adventure of La Richelandière in Saint-Etienne. The

life of Pierre Gagnaire is made of many friendships, including some of his longtime patrons, and these relationships feed his cuisine. It is at the heart of this caring circle that his cuisine continues to blossom and morph into the chef's vision.

Other people hold a great importance for Gagnaire. Cooking was a profession he didn't initially choose, but it found its purpose the day he realized that it could be both a means of communication and a tool of seduction. It may seem a little naïve, but this allowed him to find his power and help him develop his ("modest," to quote him) craft. Of course, cooking is much more than that—in fact, there would not have been any seduction if it had not been for something else, something that made cooking more than mere nourishment. It took time and a developing of maturity for Pierre Gagnaire to accept his talents, to find out what his strengths were and what made his cooking unique, and bring out his ability to let go of preconceived ideas and dare to show his emotions. What was then a timid exercise is now an expression of genuine generosity. It may not seem appropriate to talk about generosity in the context of a gourmet restaurant, but that is what it is all about. In fact, Gagnaire is fully aware of this situation and is almost apologetic, which adds to his generosity. You'll see this is some of his creations—the gift of an infinite palette of sensation, where his primary concern is to expand the emotions.

His kindness goes beyond the generous content of the plate. You'll see Pierre Gagnaire

is in his dining room walking around at the end of the meal as if he were collecting his accolades, but you'll also see him at the door welcoming guests as they arrive. His kindness is also seen in what he calls the "modesty" of his art—the chef putting his talent to the service of his clientele, regardless of who they are and whether they have come for a special menu or the simpler market one. His duty is to respond, within the realm of his possibilities, to any desire that enters the minds of his customers: a fruit tasting, a craving for a salad, ordering part of a dish or part of a menu. But he goes beyond simply responding to requests; he tries to do so Gagnaire-style, meaning to create a dish, a fruit plate, build a menu inspired from those new constraints. Once again, under a new guise, we see this passion for the instant, the cuisine *immediate*.

Gagnaire's old-fashioned sense of elegance and politeness, reflecting moral strength, is a trait he both attributes to Chantal, his wife and unconditional partner, and, at the same time shares with her. While this may not be the place to discuss their marriage, it is necessary to stress the link that units them, as without it Gagnaire's restaurant would not be what it is. This is not in respect to the cuisine, the warm welcoming, or the atmosphere—they both have great respect for their clientele and their staff, and their enduring friendships are the perfect testimony. This is more about Chantal encouraging the chef to accept his talents. After the forced abandonment of La Richelandière, Gagnaire was able to start over because of her belief in him, her vigilant presence.

Today, the calm is back—if you can call a restaurant a quiet sanctuary for those who run it! Gagnaire looks at his wife's uncompromising strength as the source of his creativity. She is his first critic, necessary to any artist, and at the same time a source of comfort. Their trust for each other was most apparent during the move from Saint-Etienne to Paris. Chantal calls herself the "chef's wife" on the restaurant's website, an understatement. Her role is far greater than managing the restaurant. Thus she most likely shares with the chef the same drive to focus on the essential.

The aesthetic of the plate has great importance for Gagnaire. We also should mention his new tendency to "remove" from the plate, which may seem like a contradiction. At his restaurant the composition of the plate is always well structured and singular, and with ingredients so numerous that, at first, you may not know where to place the fork. But just as the adornments in baroque architecture aren't there just to look pretty but to give motion to space and create openings toward the sky, every ingredient on Pierre Gagnaire's plates serve a purpose. If he chooses to serve whole chive sprigs, it is so we can pick them up and lightly chew on them while "perfuming" the palate. Pierre Gagnaire is the great producer of his cuisine, with the intent of a baroque artist. He leads us to discover this first by sight, using colors, relief (some elements "fly" over the plate), then with taste. Dance is also part of his vocabulary—the waiters who lay the dish with its various elements in front of you perform

a sort of ballet, but there's also the ballet of the ingredients, which sends signals to one another, and invite you. . . .

Since he relies on spontaneity and instinct, it is understandable that Gagnaire finds the concept of a dish of greater importance than the recipe, since the latter can easily change. The concept is a constant. Thus an ingredient can move from one dish to another and find itself playing a slightly different role because that is how the chef decided he wants it today. The ingredient may also be replaced by another with similar texture and aromatic power (a royale, a gelée, a cream). Examples of such transmutation can be seen in two versions of the Grand Dessert, November 2000 (menu 18) and in February 2003 (menu 5). The croquant "à la rose" (rosewater gelée/tube opaline)/rose-flavored cream diplomate/fresh lichee nut/fresh raspberries/fresh flowers) becomes "black currant diplomat cream, violet flowers" (tube opaline/crushed black currants/violet cream/fresh and candied violets/black currant syrup). The numerous versions of the "Chocolate Pierre Gaganaire" seem to follow each other in a game reminiscent of the literary explorations of Perec or Queneau. During the fall season, a Bailey's-flavored ganache square/golden raisins/cocoa crumble/ganache/sheet of muscovado caramel/couverture (chocolate) fondue. In a glass on the side: cacao gelée/pimiento/coffee/coffee-flavored nougatine/chocolate cake/pistachio foam/cocoa tuiles." In the winter, the dessert becomes a chocolate and cocoa cake/bitter chocolate bar/prune purée. In a glass: vanilla cream/cocoa-coffee

gelée/whiskey caramel foam/cinnamon cookies/ginger nougatine. There are many other Grand Dessert menus, and over the years it would have been surprising not to see ingredients, as soon as they appeared in Pierre Gagnaire's world, take the place of others ready for retirement.

One thing is certain: nothing is definite in Pierre Gagnaire's universe, and the chef always will be looking to expand his freedom. "Molecular gastronomy" is only a tool to serve his creativity. Without talent, the most beautiful device in the world will produce a sterile result. The improbable encounters that Gagnaire has been coming up with in his dishes for the past twenty years are reminiscent of some surrealist images with their striking beauty. These "gustatory arches," collisions of flavors, but also peaceful moments lead us in to a surprising, modern, and seductive game. Gagnaire's cooking took a long time to evolve—we had to wait for Nouvelle Cuisine to put something new in our pots. Gagnaire came onto the scene at that time—he followed those new cooks and yet was already breaking away. When he was able to embrace traditional cuisine and played with it freely, he made it explode. From the shards, he created his own cuisine, abandoning traditional guidelines. Today his cuisine seems limitless, open to the world, and rich with possibility. His structure is strong enough to contain all the various encounters and inspirations and perhaps let go of a certain elitist element. Gagnaire's cuisine is the legacy of the classic Grande Cuisine Française, but with an added dimension, a

generosity that the former may have already lost. This cuisine not only creates its own freedom, ensuring its evolution, but it also remains accessible to the diner. Conceived as a dynamic ensemble, it offers surprises and lets us play in a baroque game. Reading the menu, the words invite you into a dance, suggesting rapprochement, shaping a dream . . . but the ultimate pleasure is still to come, on a plate that offers itself as a gift.

THE MENUS

125

1. JOHN DORY AND SCALLOPS
John Dory fillet poached in a spicy butter,
 small red pepper from Guernica
Scallop salpicon Tandoori melon enrich Gallia
Pancetta with salted caramel, romaine lettuce
 and green papaya

2. THE TRUFFLED SUGAR
The cookie soufflé Richerences
Ice cream nougat with dried fruit
Pinch of salt from The Himalayas
Ricotta with sage honey
Lazy cream in a box
Marron glacé and Malabar peppercorn
 ice cream bar

3. MAD CRAB
Line-caught bass or mullet Marinière-syle,
 rouget with capers from Nicchia, cured lard,
 medley of carrots and essence of green crab

4. PORK
Pork loin (black pigs from Saint-Yrieix) seared
 in goose fat, slowly braised with sage, savory,
 and lemon thyme
Galette of prunes and cured lard from Colonnata
Black pudding ravioli, wine sauce and strips
 of Belotta ham
Crisp pig's ear, sabodet sausage and dandelion
 salad Robert

5. GRAND DESSERT, FEBRUARY 2003
Mandarin gelée
Black currant diplomate cream, Violet flowers
Confit of Boskoop apples, nasturtium syrup
Ice cream made from hazelnuts from Avelina
Chestnut tuile and quince
Fruit salad of Muscat grapes, lichee nuts,
 and kumquats
A round the Victoria Pineapple
Chocolate end-of-the-year "Pierre Gagnaire"

6. END OF WINTER 2003
Thin galette of crayfish and sweetbreads
 perfumed with cinnamon, baby spinach
 coated with a sweet walnut butter
Dried cèpes and vegetable semi-confit, glazed
 fatty tuna, crispy bok choy leaves

7. CATALAN LANDSCAPE
Mariniere of small squid, cuttlefish, and
 small octopus with Guindilla peppers
Stuffed squid with grilled pimiento peppers
 and fresh prawns from Palamos, radicchio
 fondue
Creamy salted cod with squid
Grilled fressure (heart and liver) of lamb,
 fideùa (paella with pasta) with young rabbit

8. MEDITERRANEAN

Hake fillet cooked slowly in a citrusy vegetable
broth

Red tuna confit, paste of garlic from Lautrec,
eggplant cannelloni

Jumbo shrimp from the Algerian coast veiled
with a saffron-chickpea tuile

9. DEEP SEA

Three types of Oysters:

Horse Foot Oysters (twenty-five yearsold,
Madec), Papillon Oysters (Hervé), Fine de
Claire Oysters (Gillardeau), and Prairie clams

Young mackerel soup with seaweed

Glazed black gnocchi gratin

Scampi-style cuttlefish, essence of green crab

Rye dumplings with aged Beaufort cheese

10. THE ORIENT

Red pepper gelée with saffron, small purple
artichokes flavored with vadouvan (Indian
spice mix), pattypan squash with green
papaya, Boston lettuce stuffed with
Vietnamese mango

Pastis (flaky pie) of squab Gauthier, cream
of almonds, and salted hazelnuts

Carrot confit in strawberry tree honey
emulsified with argan oil

11. VEAL AND FROG

Organic milk-fed veal:

Seared veal

Frog's legs coated in a fine polenta

Braised veal with Swiss chard

Jumeau and liver prepared as a vitello tonnato

Braised kidney with lettuce

12. LANGOUSTINES

Four preparations of langoustines from
Brittany:

Sautéed Terre de Sienne

Mousseline seasoned with berbere, butter
whipped with lemongrass

Tartare with green apple and ginger, smoked
gelée, toasted carob

Grilled with a nougatine of thyme vinegar

13. VEGETABLE MENU

Gelée made with lemons from Menton with
combava (type of citrus fruit), freshly picked
organic green vegetables

Rye dumplings with bocconcini

Tomato and basil in crisp pastry, green and
yellow pattypan squash with coppa (cured
meat) from Corsica, fresh herbs and red
currant juice

Cucumber granité flavored with white tea
from Hunan, bitter almonds cream

White asparagus flan, morels braised in Maury
wine, spring onions

Ravioli of spring garlic and truffles, young
turnip and Boskoop apple

SAVORY

A conversation
between tender dried
leaves of Chinese
cabbage and crisp
slices of grilled bacon.

BEAUTY IS A REBELLION.

130

Contrary to what is said about my cooking, flavors inspire me first and foremost. The visual comes later. When I serve this composition my primary concern is to marry the delicate flavors of the lettuce with the crunchiness of the bacon (actually a Corsican dish from Terranegra). Only later do aesthetic considerations arise. The beauty of a dish is a visceral, passionate reaction to the mediocrity that often angers me. As a result, beauty has become a battle cry, another goal. The first thing is wonderful flavors, of course, but the next impulse is satisfying the eye. Beauty quiets me, calms me. It lets me converse with something other than the palate. Is it the soul, the dream, the memory? . . . I don't know. But by designing this dish beyond expectations, I feel this strange frisson.

In the golden shell of
the roasted onion skin,
a scallop permeated
with its perfume.

SALVAGE.

132

Everything on the plate should be edible. Otherwise, the dish verges on mere decoration. I have salvaged this onion peel because I loved its gesture. This primitive shell immediately found its place on the plate with a grilled scallop. Served just as a peel it still could have made the dish but, still warm, it gives off all of its perfume. The peel then becomes an active player.

Guacamole pairing
avocado, banana, and
sorrel: to savor with
a quetsche plum confit.

FRIGHTENING ALCHEMY.

134

Sometimes it is tempting to enter into sophisticated compositions, multiply the layers, the counterpoints, embark into a frightening alchemy, and create a delicious murkiness. This combination of avocado cream, banana, and sorrel tries to be the exact opposite. The ingredients are strong. They are neither evocative nor suggestive. It is not, however, a dish with sweet, lazy flavors, since the plum comes to trouble its well being. It resists the harmonious palette of flavors, while at the same time echoing it. Take a good look—avocado, plum, banana, sorrel: they're all involved, no one is turning the situation to its own advantage.

ON THE TRAIL.

136

To me, this picture calls out to the imagination. This is how I cook, and how I want this book to work. It goes beyond the ingredients. Obviously, you see this pumpkin, a carrot juice flavored with orange, toasted pumpkin seeds, thin slices of Parmesan. But that does not make a dish. And yet, this is precisely where the story begins. You could add a prawn tartare, a red pepper bavarois (custard). This is how a recipe evolves. The ingredients and pictures do not give away a recipe, only a trail.

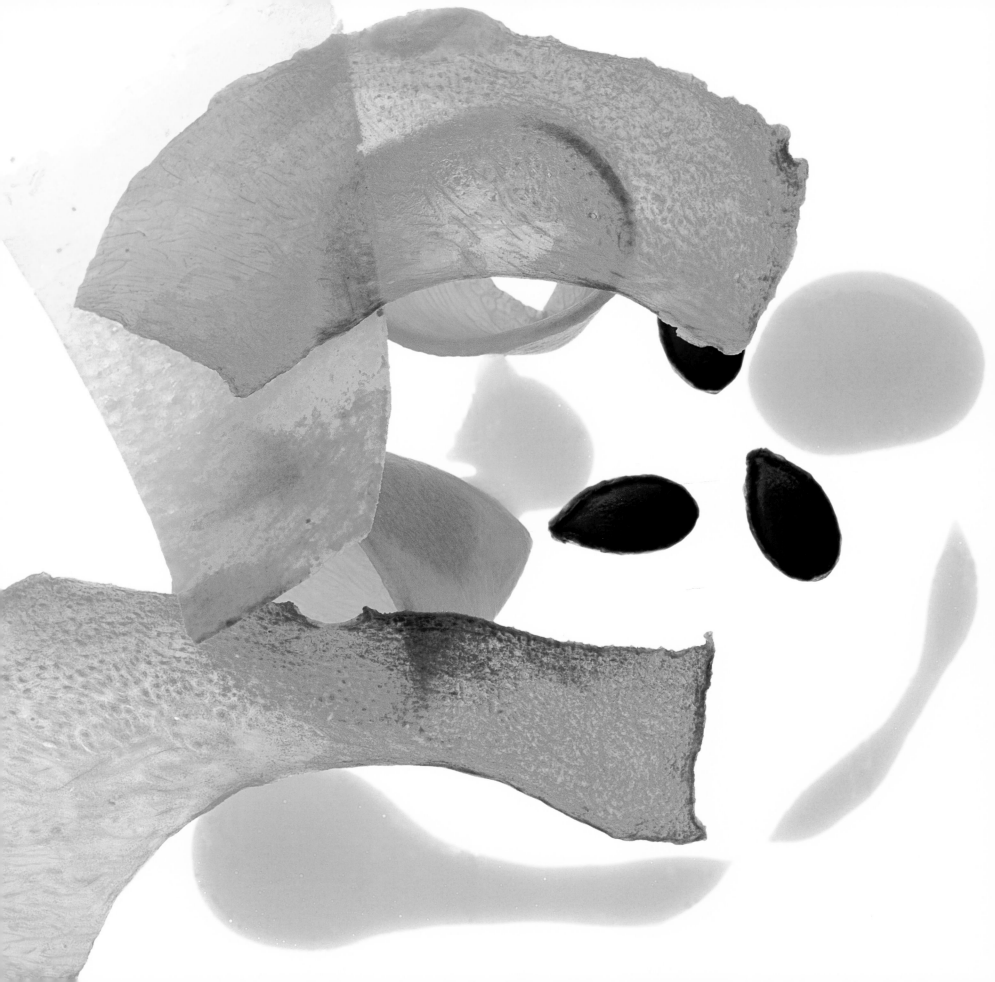

Solar, the
unctuousness of
an egg yolk uniting
the earthy flavors
of the green
asparagus with the
musky scent of the
black truffle.

MERCHANT OF THE SEASONS.

138

The asparagus meets the truffles; this dish is about emotion. The asparagus arrive like a conqueror in its insolent sprightliness; the truffles have taken the underground route, bringing with them this magnificent pathos, subterranean and explosive. We are in an endearing time of year; the menus are changing, unrest is here.

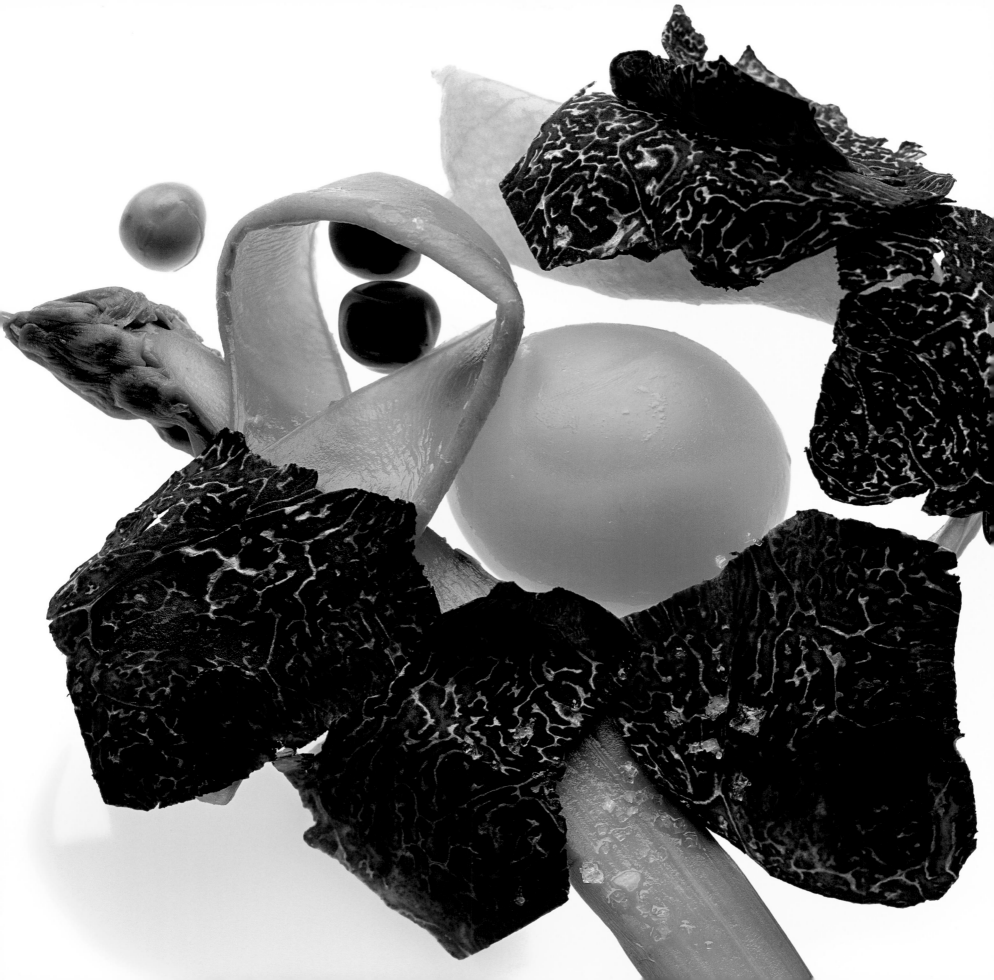

Perfectly golden,
mini baguettes spread
with pistou, garnished
with raw gherkin
pickles, chives, and
marinated mackerel.

THE LONELINESS OF BREAD.

140

U sing bread in a dish is a big problem. Bread is mostly used, unflatteringly, to dunk in a sauce or to push morsels of food onto a fork. And yet bread is one of the pillars of our culture. At the restaurant, it enters into a curious equation: either it is uninteresting, or it's so delicious it staves off the appetite. I want to take it out of this ambivalent role and recast it as a sandwich such as this one: mackerel and cebette onion. Bread will find a place one day. It circles the plate for now, but I can easily see it sneaking into a corner, lifting the pearly veil of a fish, or adding crunch to a medley of vegetables.

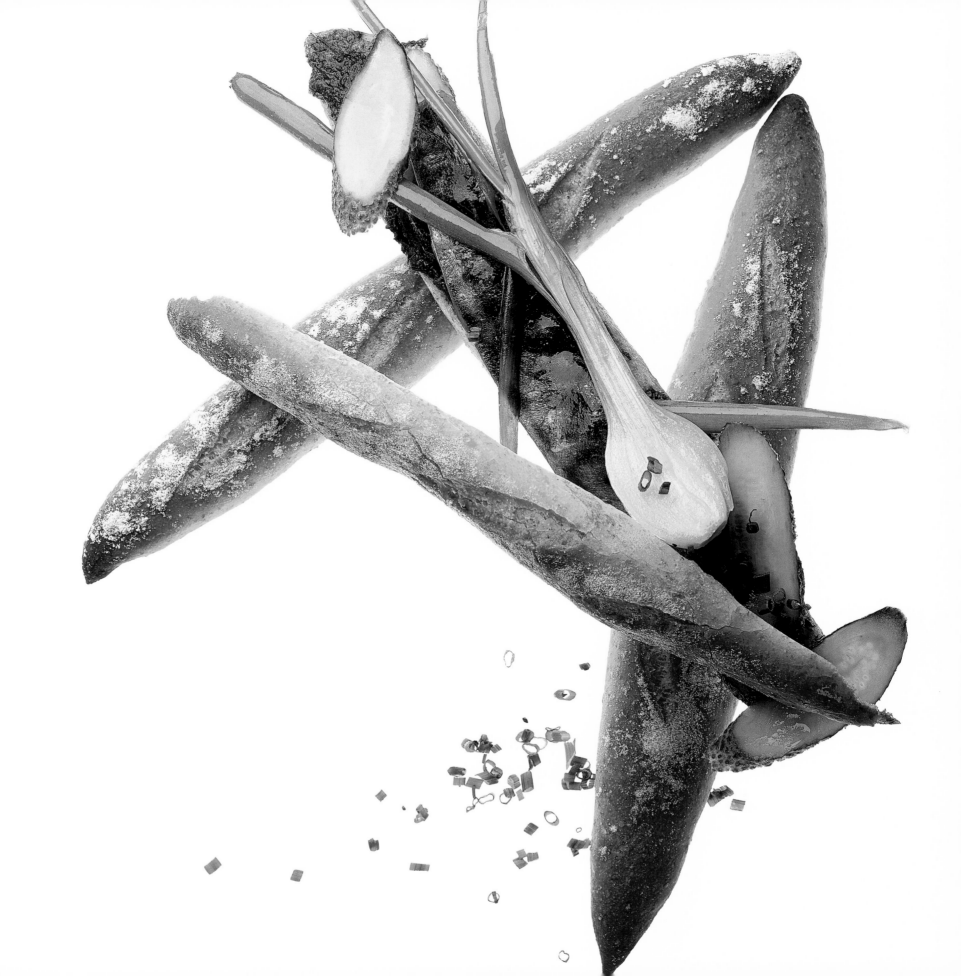

Small stuffed
vegetables—spinach,
leeks, carrots—acting
like sushi, on a leaf
of romaine lettuce
with fava beans.

ESSENTIAL MODESTY.

142

In these hectic times, vegetables have become what they once were: the essence of the earth and an essential modesty. They flourish on the menus anew, but they also have their own little concerns, which are different from those of meats and fish. On the plate, they maintain a refreshing joviality. They have a wonderful ability to reassure us, as if they are immutable. That's why, when they are cooked, vegetables shouldn't stray too far from their rustic nature, the song of the earth.

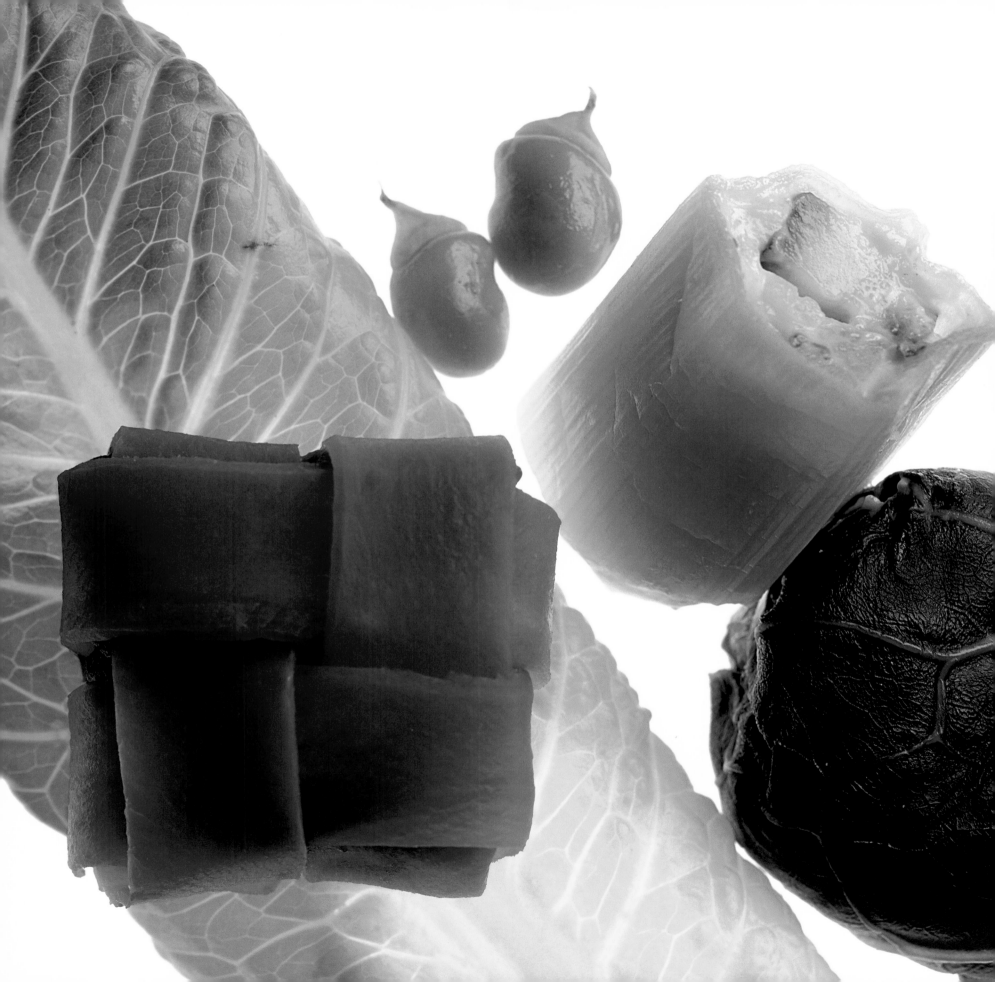

In a bunch, assembled
on a slice of roasted
cantaloupe: glazed
baby carrots and
turnips, halved grapes
and diced raw foie gras.

THE UNEXPECTED GUEST.

144

The melon suffers a curious fate. Few chefs seem drawn to it. We don't know what to do with it. It is as if we are almost resentful of its good nature, its sunny fragrance, its amber nectar. It's nearly an impostor, with its pretty face wreathed in constant smiles. Nevertheless it retains, along with its good nature, an element of a trickster. Here it is with carrots glazed with their own juice, and foie gras. What's the melon doing here? "Nothing," it might answer with an ingenuous shrug. And still, it gets in the middle of everything, toys with the palate, brings in its suave, round notes. In the end, it almost shoved aside the carrot, plays off league with its texture, and shines insolently.

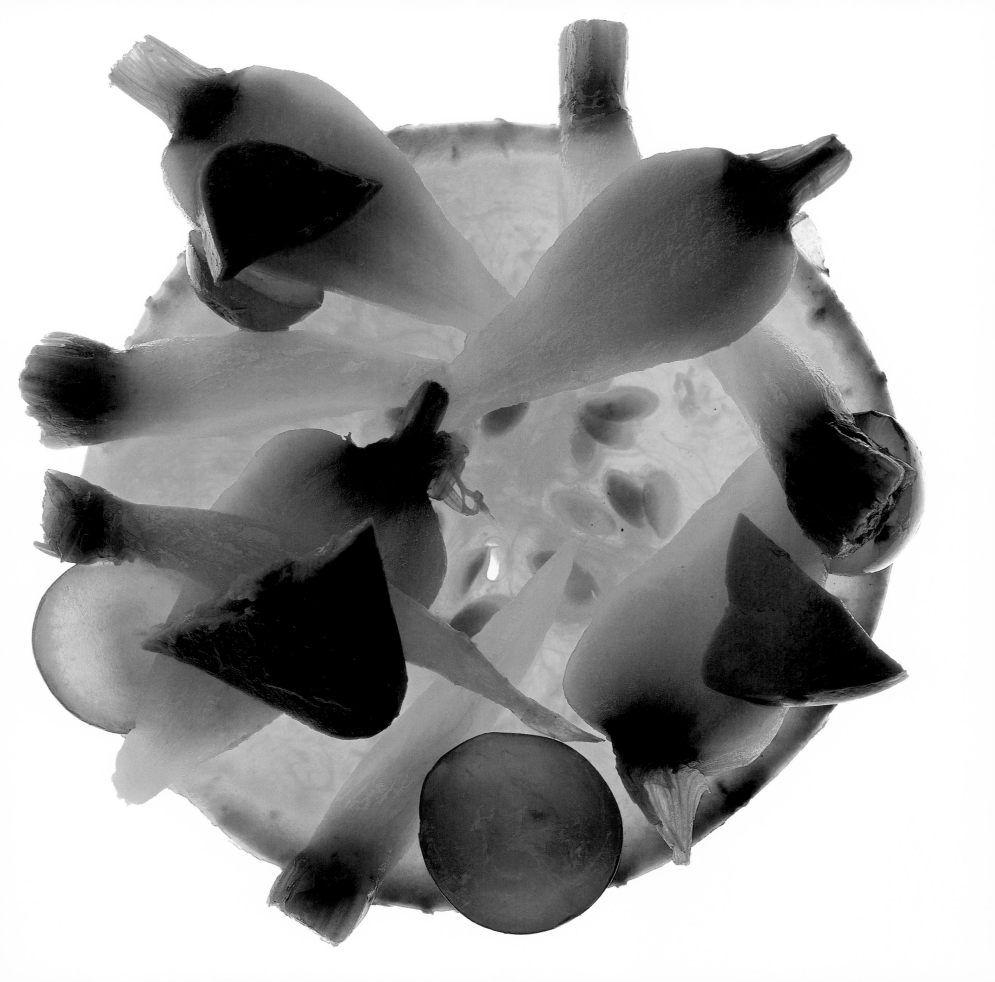

It's Too Much.

146

The spiny lobster will soon become a prehistoric animal. Its cost is astronomical, and in truth there are times when it is better to go without than to put such indecent prices on the menu. That's a pity, as it's a sumptuous food, with its sweet, delicate flesh, its hint of vanilla, reminiscent of a scallop. Faced with such an ingredient, you almost want to draw back from this blinding explosion of subtleties. Then, before you close your eyes, you lay it over a lemon balm leaf and a few passion fruit seeds.

Exquisite amuse-
bouche: mini
gingerbread spread
with paprika-flavored
ricotta and a slice
of butter radish.

ON TIPTOES.

148

The meal often begins with a paradox. The aperitif is a strange crossroads; hunger gnaws, but the appetite is stalled. You're waiting for the follow-up; thirst and hunger rise up. The meal is being plotted. The goal is to whet the appetite without breaking the spell. Hors d'oeuvres can spoil it all by being too intrusive, heavy, or filling. So we walk on tiptoes. Like an opera, a prelude should provide the tempo without revealing the score. Here's gingerbread, juggling its alliances; ricotta with paprika for the high notes, a slice of radish to cool down the ardor. I can easily see a Pouilly-Fumé contributing its happy bevevolence. After this, the meal can soar.

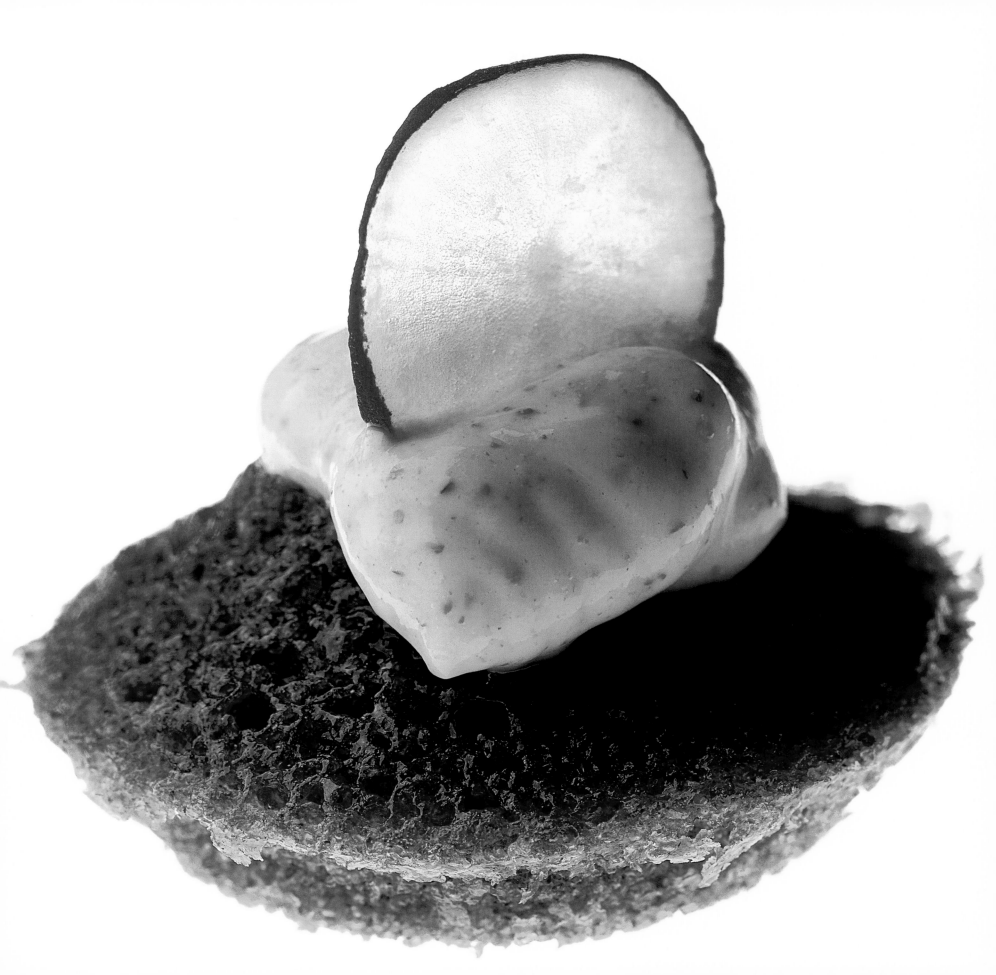

A scallop with a sprig
of thyme is wrapped
with a pink lettuce of
the sea ribbon.

STARTLE.

150

The scallop has the tendency to make a dish run around in circles. It charms and seduces, but sometimes we just want to shake it, to make it lose its nice sweet temper. The sudden arrival of the seaweed should do the trick. The seaweed was cured in salt like cod, then washed to remove some of the saltiness. Needless to say, the scallop is startled. Shaken without circumspection by the stroke of this sea-whip, it delivers new unsuspected flavors.

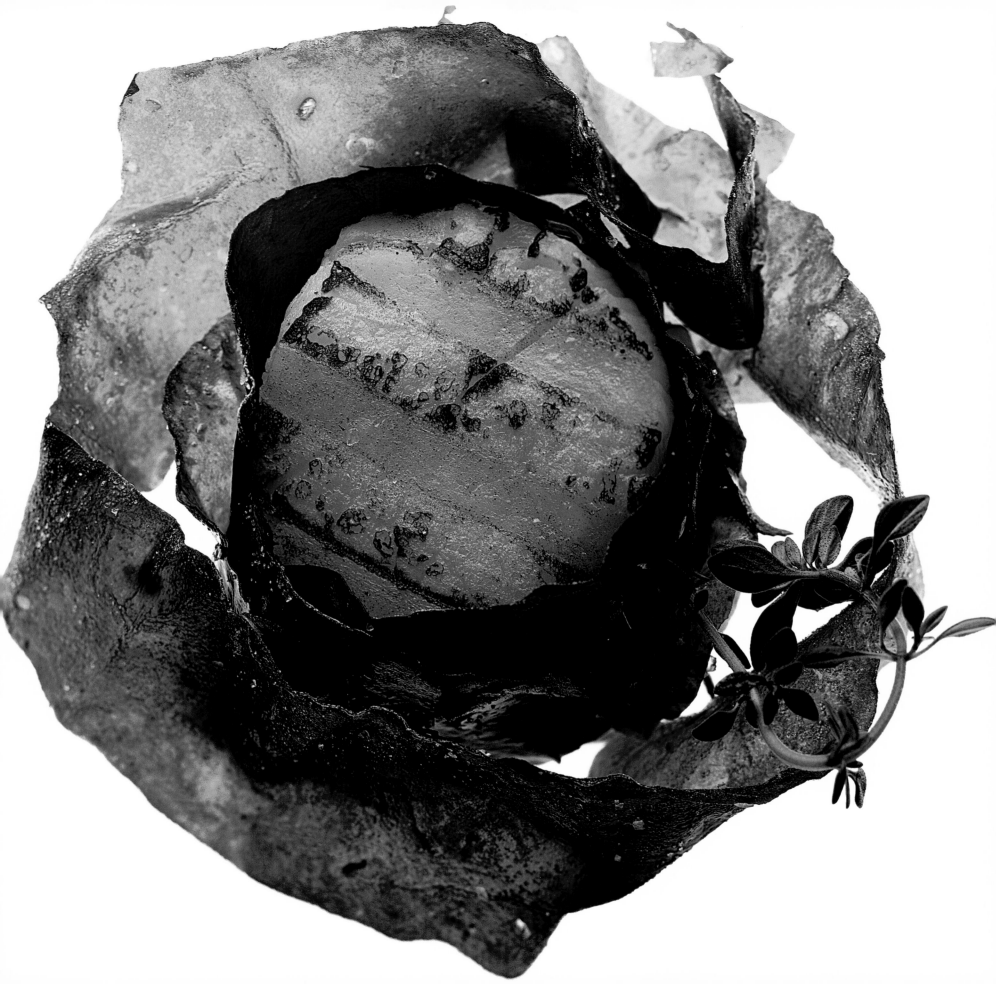

Lobster couscous
flecked with minced
chive and a leaf
of amaranth.

NOBLE DECEPTION.

152

An ingredient as splendid as lobster cannot bear sloppy treatment. Cook it on high heat, carelessly, and your lobster becomes rubbery. It was a marvelous thing; now there it is, mediocre. That's why when people talk of the inner nobility of a food, I remain pensive. Modify your technique, start the lobster out on gentle heat, let it roll in frothy butter, then turn down the flame, gently remove it, and turn it over with the tips of your fingers. Carefully. Respect its extreme fragility.

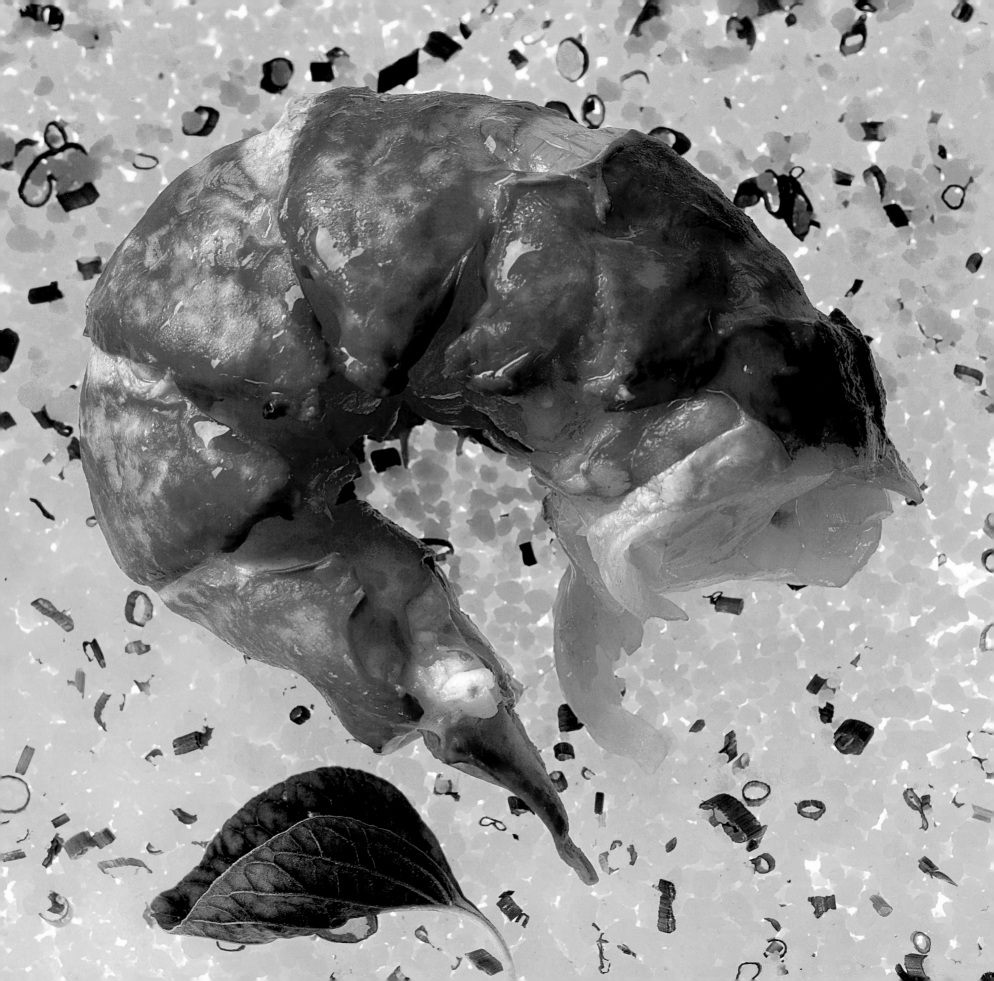

Crisp-melting amuse
bouche: foie gras,
hazelnuts, cocoa beans
in a shell of a
semi-puffed pastry.

ON THE WAY.

154

At the risk of shocking, when I look at this plate I say: I don't remember it anymore, I just don't know. I've lost it. It is terrible, but I don't recognize the ingredients anymore. Some tuna, haricots … of course, but this composition ran away from me. It's almost frightening, and at the same time it's reassuring. Dishes, ideas, and emotions are constantly crossing my mind. You have to catch them immediately, otherwise they continue on. They don't even look back. This dish is giving me the cold shoulder.

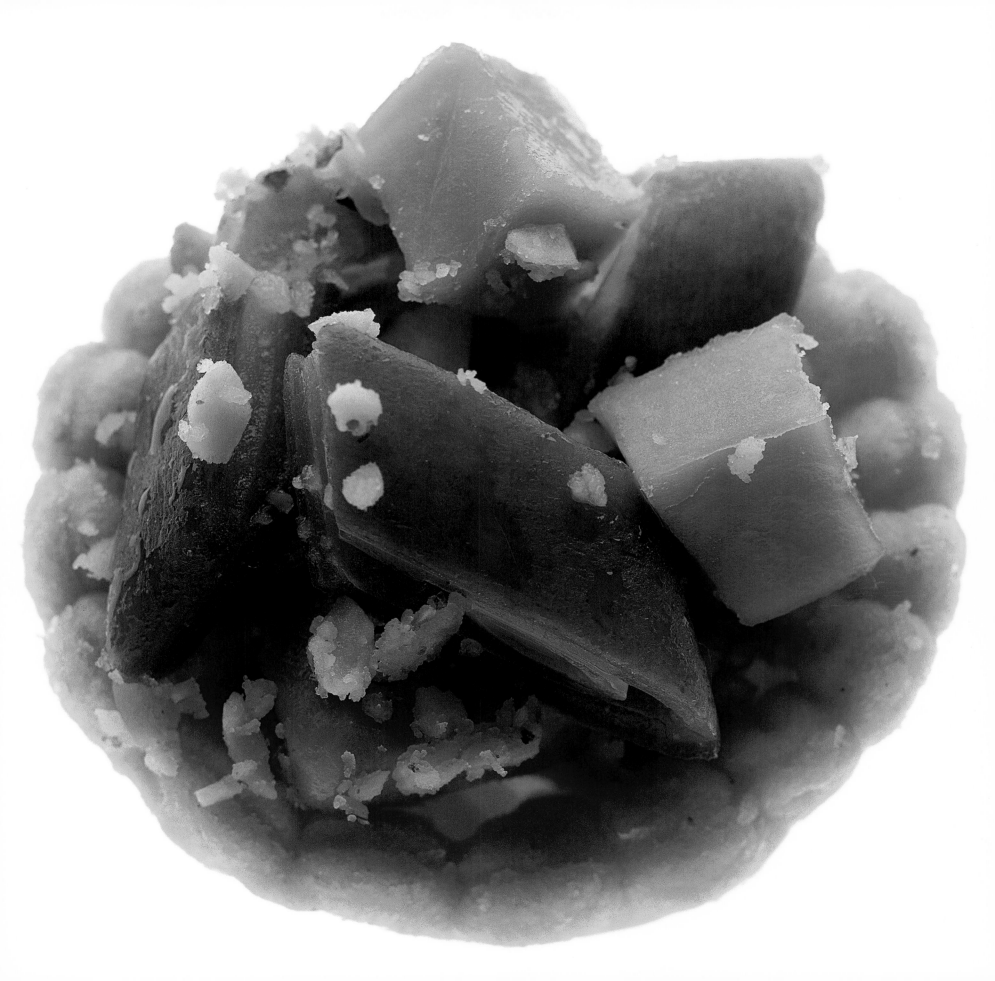

Pastry filled with
John Dory in a
black-and-white
sauce with
gray shrimp.

Where Does This Come From?

156

To be perfectly honest, I do not even know what is in this picture. Obviously, there is a puff pastry and two beautiful gray shrimp, which were just roasted, very lightly, to allow their fresh briny juices to explode under the bite. I scrutinize it. I recognize that, on a regular basis, my dishes enter my reveries. They even have the audacity to materialize, catch my eye, and pose for the picture. I probably dreamed it, and now it has vanished.

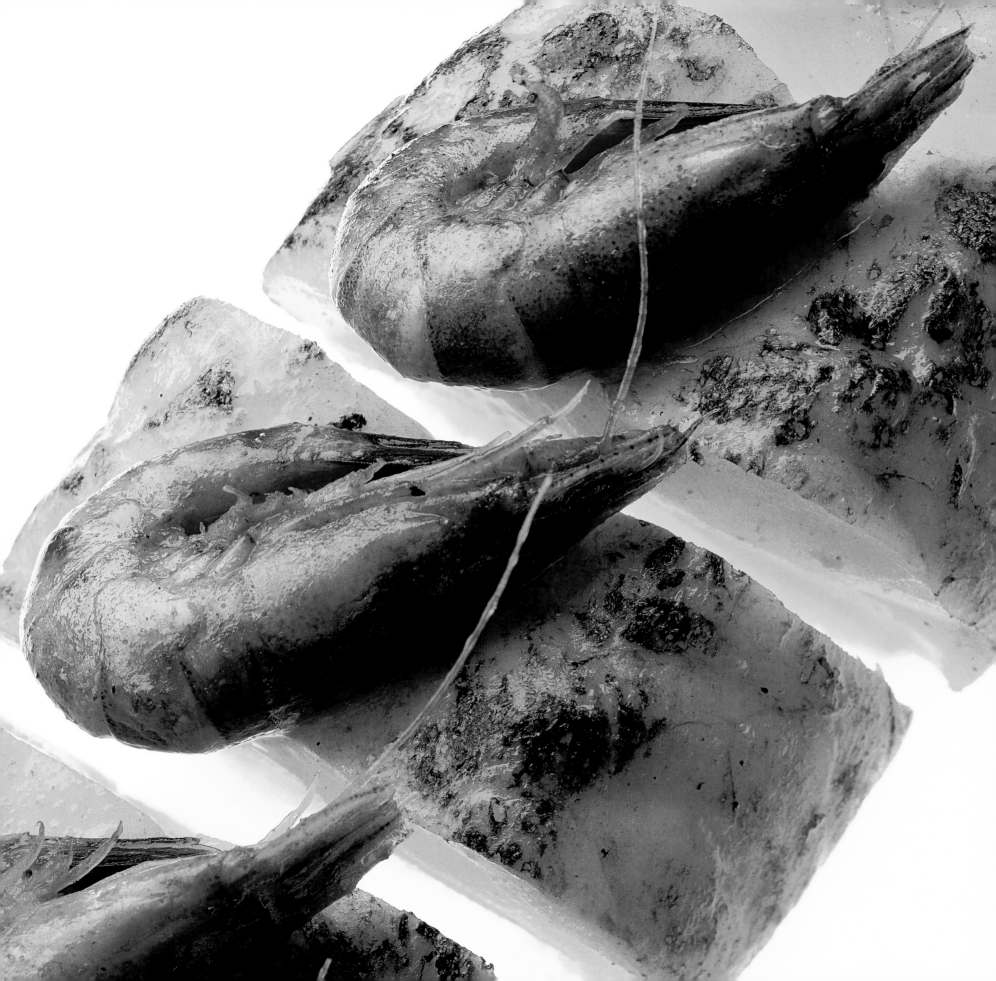

Underneath a
crisscross of fried
spaghetti: a
Langoustine tempura
wrapped in
a ribbon of leek,
placed on a lettuce
leaf, and a slice of
dried eggplant.

INTEGRITY.

158

L angoustine, is probably the star dish of gastronomy. As soon as it appears on a menu, it is gone. Yet it is an extremely fragile ingredient; it should be cooked with the greatest care. I believe that deep-frying brings out its true personality. The constant even temperature reveals its inner character. Under its crisp protective coating, the delicate flesh releases its sweet, smooth flavors.

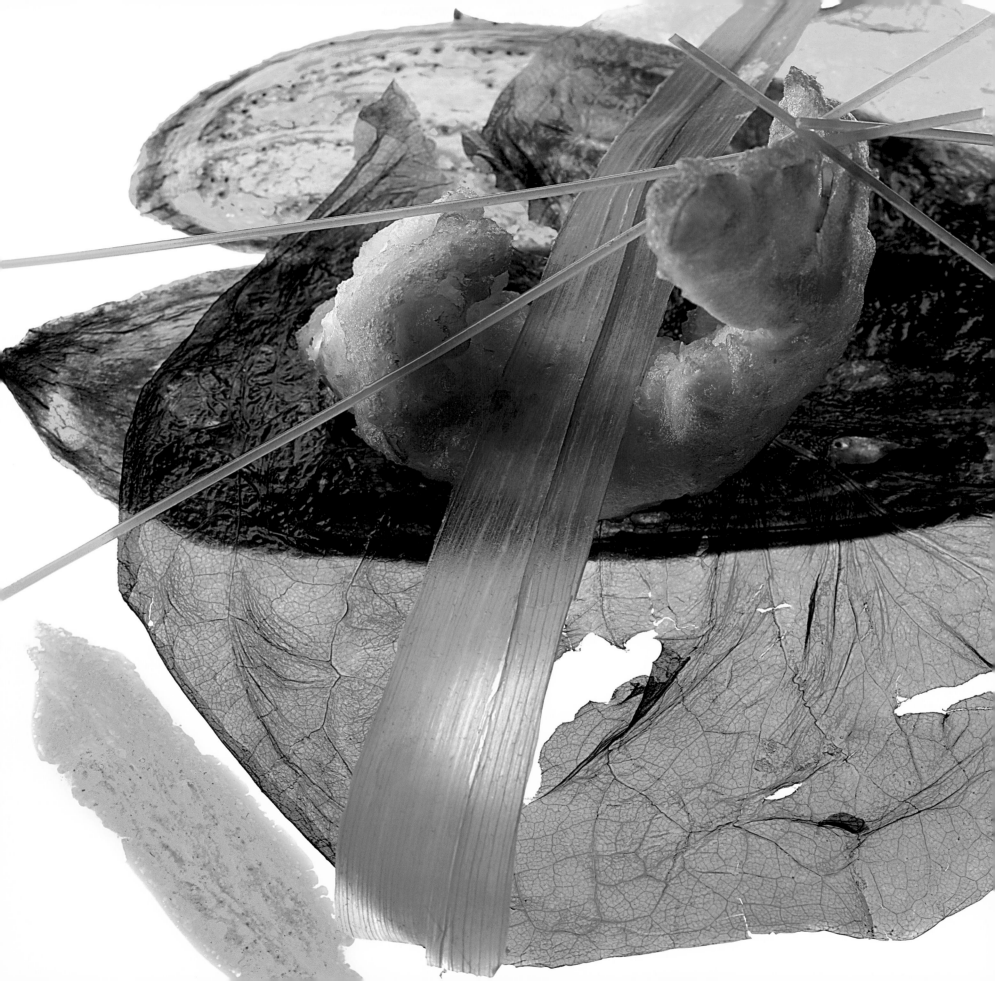

LISTENING TO THE SERVILE.

160

O nce in a while, nothing wants to emerge from some compositions. That's simply because each element has found another. They have created a circle; they dance among themselves. Indeed, it is a little strange to find this crab mousseline holding hands with a tartare of langoustines. Now, almonds and a brunoise (small dice) of black radishes join in. Along with, to enlarge the circle, a few leaves of mesclun with their piquant herbaceous taste. They remind me of a chorus. There are low voices—the langoustines, the almonds, the cooking fat from the crab. A few high notes stand out. Pay attention, listen.

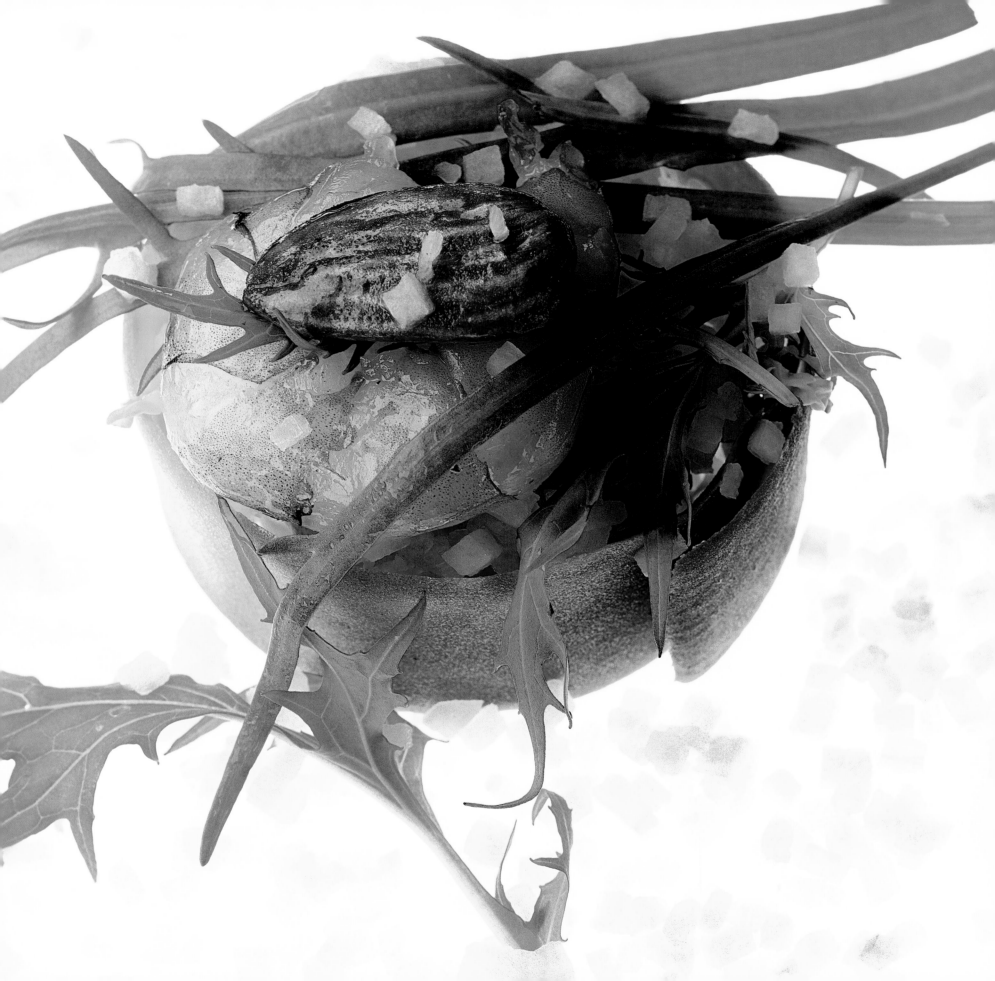

Delicate artichoke
tartlet to accompany
morels in cream.

IRREFUTABLE.

162

Naturally, this bundle of chives is superb; it sets off the dish (in this case an artichoke tartlet), gives it a definite, irrefutable character. But I already hear a few reservations. Are these chives only for aesthetics? Of course not. I want the guest to take up one of the sprigs, nibble on it, chew it, and suck out its nectar. Only then can you dive into this dish with a singularly flavored palate. The chives' presence then becomes justified.

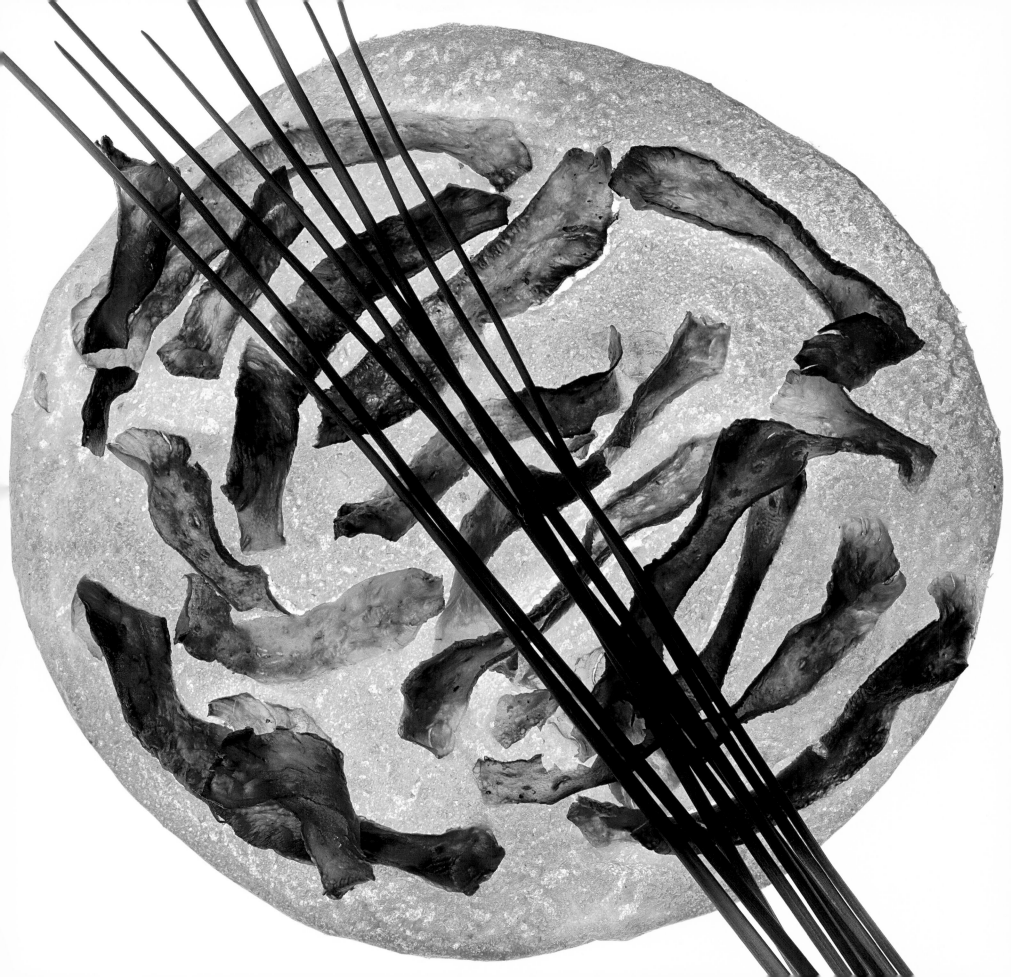

Oysters in beet gelée,
fava, sweet peas,
and thin slices of
Beaufort cheese.

THIS EMBARRASSMENT.

164

All at once, looking at this picture, I am—how can I say it—overcome by embarrassment. In this composition (oysters, fava beans, beet gelée, Beaufort cheese), the fava bean siting on the oyster is like an inquiring eye. The interrogation borders on reproach. "What have you done to me?" the oyster seems to be saying. "God only knows!" responds the fava bean. I would like to quickly modify this recipe, replace the pronouncement, pursue the intention. Do anything but leave it as it is. Every dish, in its roundabout way, in its twists and turns, slips you a question, but rarely does it pose one so bluntly. This embarrassment. . . .

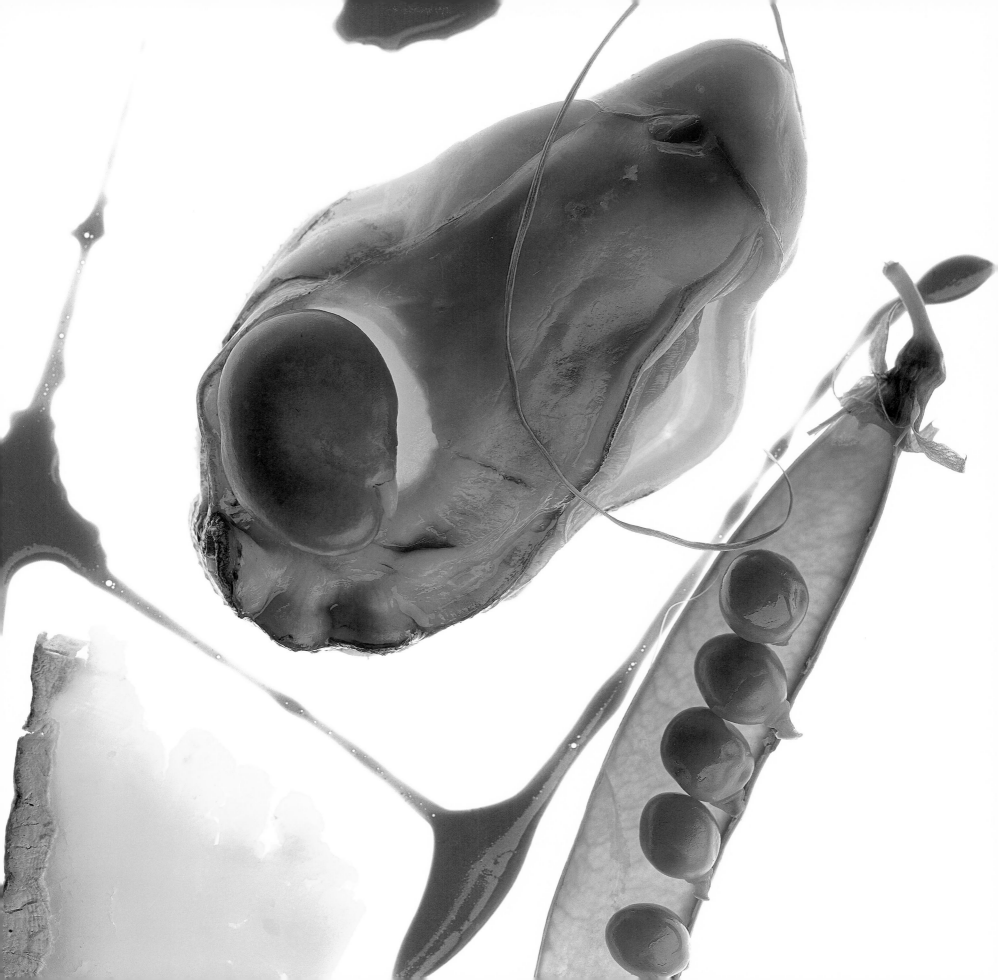

Layered over
translucent fennel
are grapefruit wedges,
a julienne and
crumbs of truffle.

Excuse Me?

166

Putting together grapefruit and a crumble of fresh truffle may seem a little misguided. On the other hand, it may be an original creation. I have a feeling that we are in the latter scenario. We use a grapefruit of the ugli variety, from California, that can only be found during a brief period in winter. It is sweet, juicy, fine-textured and smooth, with only a slight bitterness. When the lightly creamy Périgueux sauce, studded with truffles, interfaces with the grapefruit slices, something happens. The addition of fennel adds another dimension. This composition is typical of my cuisine. Things happen in layers. Tastes diverge and then weave together. We are not talking single notes, as in tapas or sushi. It's about complexity. In one spoonful you experience a range of flavors: a slight bitterness, some hindering. I could talk for hours about certain associations of taste and ingredients, but in this recipe, don't ask me how it works: I just don't know.

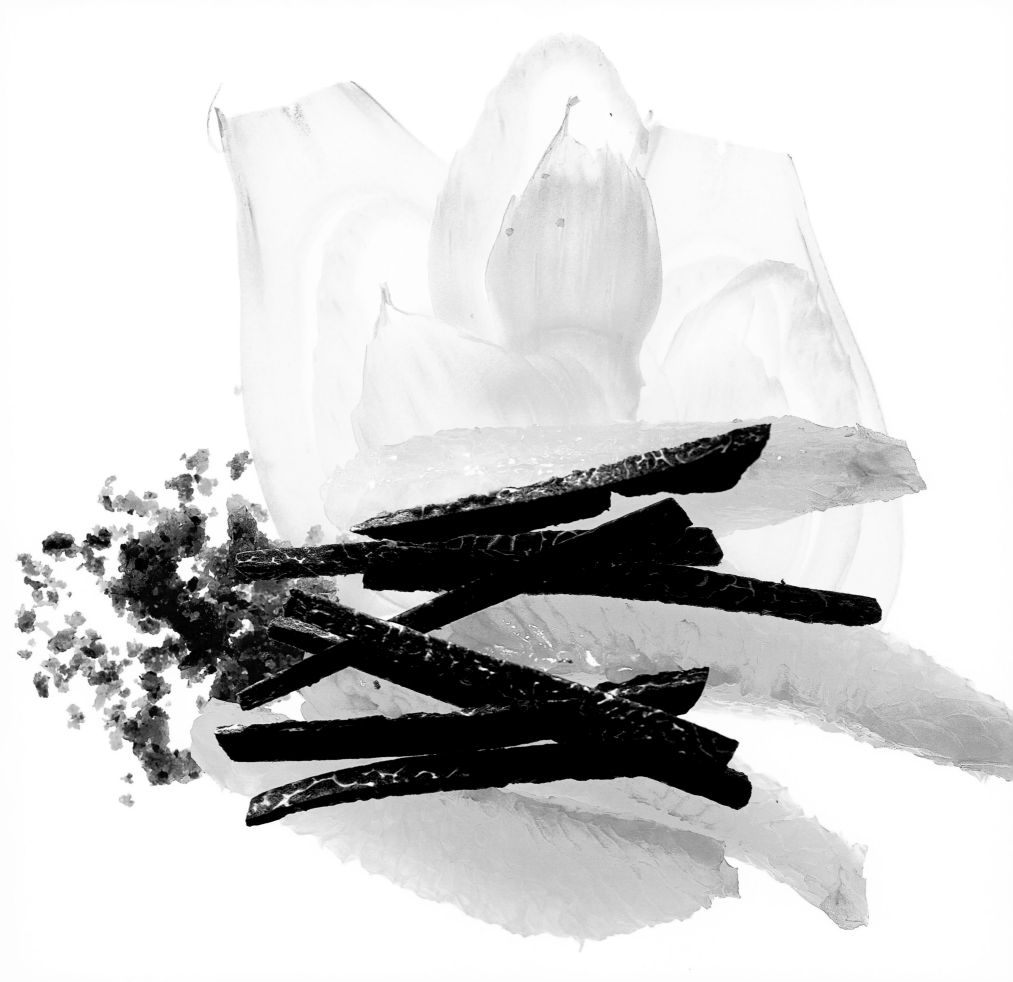

Alliance of the sea
and earth: sea bass
carpaccio with sea
beans, yellow beans,
and baby fennel.

IODINE.

168

I have such a strong feeling for this sea vegetable, which bears so many names—sea bean, samphire, sea asparagus—its salty iodine flavor is reminiscent of summer, which is exactly when it's available. Its season is short; that's why so few people are familiar with it. It is often pickled in vinegar, but this is really not the best way to enjoy it. Served fresh as a condiment, the sea bean reveals depths. It finds a place alongside a bass, sliced thin like a carpaccio, wax beans tossed in butter and a tangy Italian-style fennel.

Ultra-thin and crisp
freeform puff pastry,
crunchy black truffle,
tender ham of Jabugo,
accompanied by a
sabayon of macvin (a
walnut-scented wine
from the Jura region).

THE CAPRICIOUS.

174

It is often said that you don't become an expert at roasting meats; you are born one. The same is true for the making of puff pastry. It is an art so free and capricious that it requires constant attention. Let your working surface get too warm, and the dough becomes too elastic. You cannot linger; puff pastry requires a steady rhythm . . . working the dough, folding it, trapping moisture in between the layers. The rhythm of these gestures is precise. Only then will the spirit of the pastry take flight.

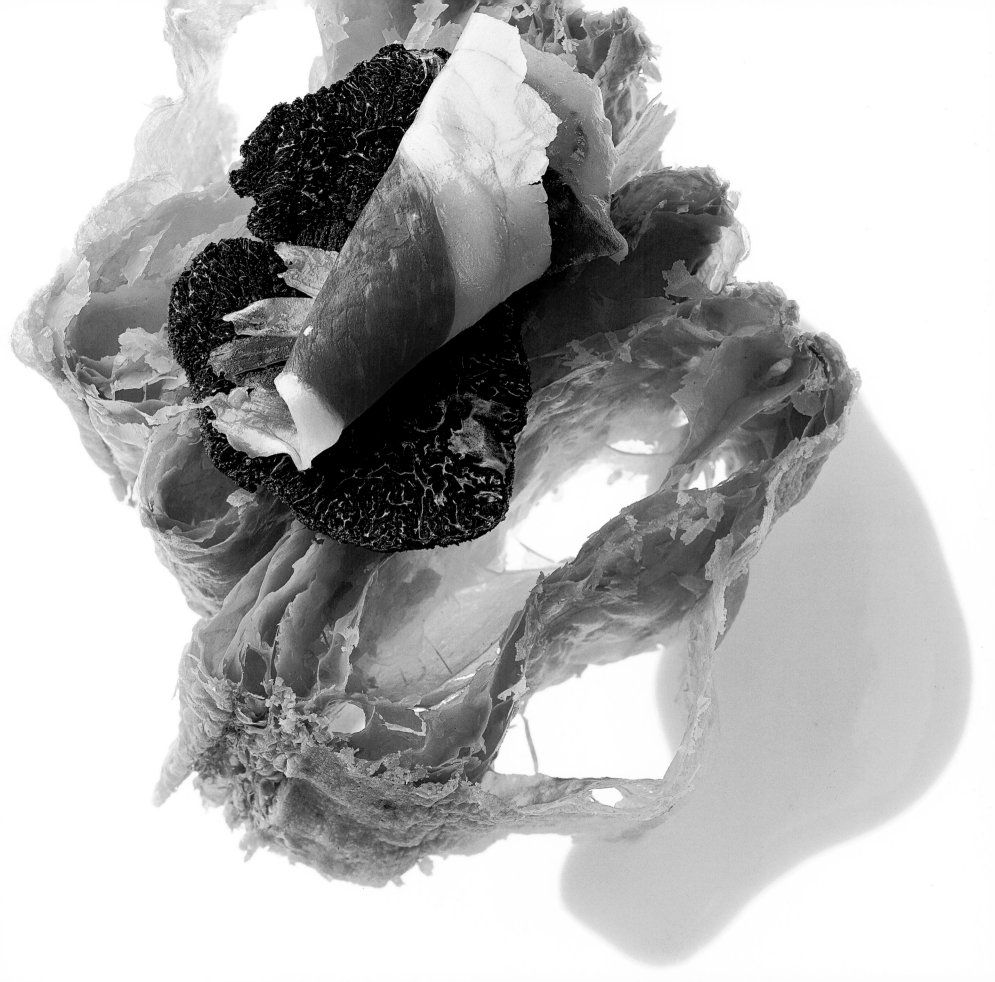

Mini olive oil pizzas, very round and thin, crossed by a ribbon of grilled red pepper.

HAPPY ARE THE SIMPLE.

When it comes down to it, we might well wonder what these pizzas have to do with gastronomy. It's as if there were two kinds of foods. The "barbarians," appealing to the hunger and the appetite (oysters, peaches, pears, pizzas, ice cream), rushing headlong, jubilant and drunken. And the others, more timid, hesitant. The simple are more thoughtful, more restrained; they possess more common sense and wit. Fortunately, the two can get along. Don't treat the simple with cautious kindness; instead add them boldly to a repast worthy of them. These very refined pizzas, made in the spirit of Italian focaccia, become a unique appetizer for six people, to be followed by a simple roast chicken or grilled lamb.

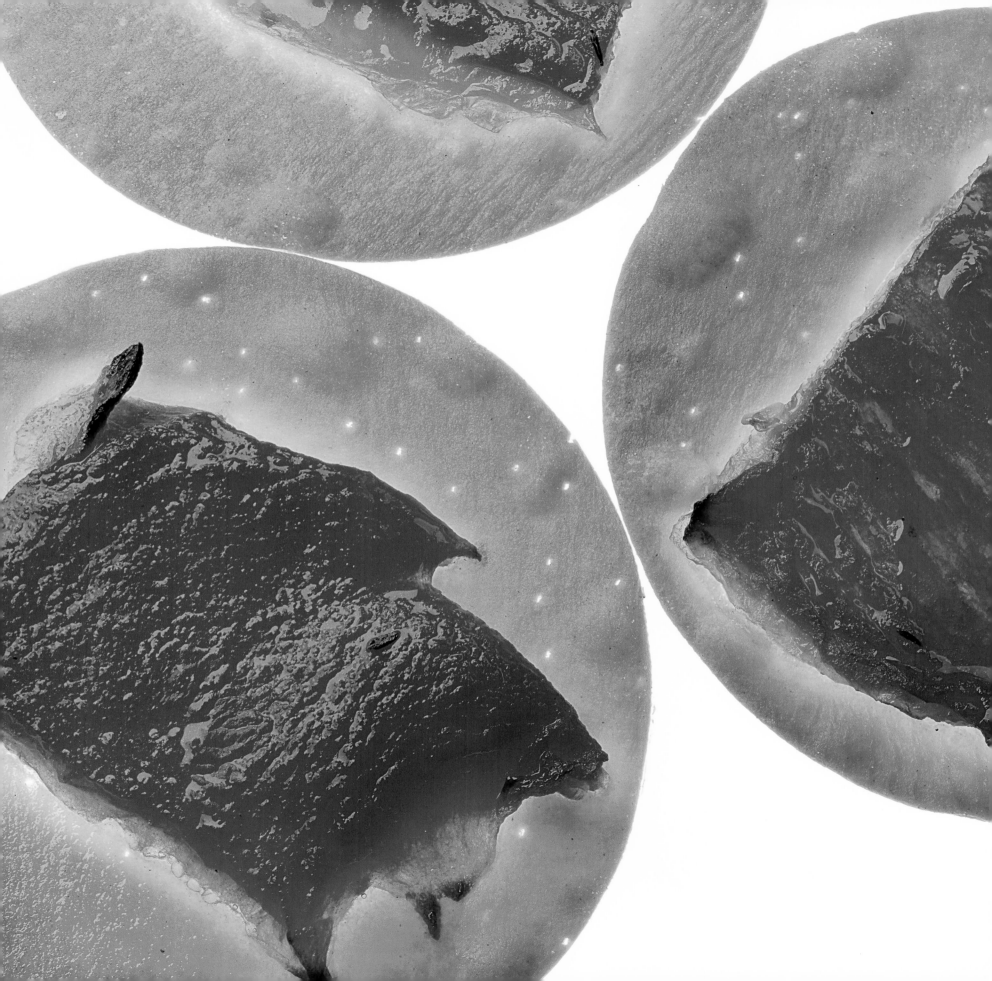

Stuffed red mullet
surrounded by sprigs
of chives and
red currants, fava,
corne de cerf, olive oil,
fleur de sel,
and mignonette.

RESPECT FOR SLEEP.

178

With mullets, you must show some restraint. They have their temper, their language; just listen to them, keep an ear to the ground. They don't require much. Just a fillet of anchovy tucked inside. They will gently bake on a bed of salt—but not just any salt. It is seasoned with red currants. fava, corne de cerf. Without a drop of fat, the mullets stretch out on top and can now sleep in peace. Their true character has been faithfully preserved and captured in their sleep.

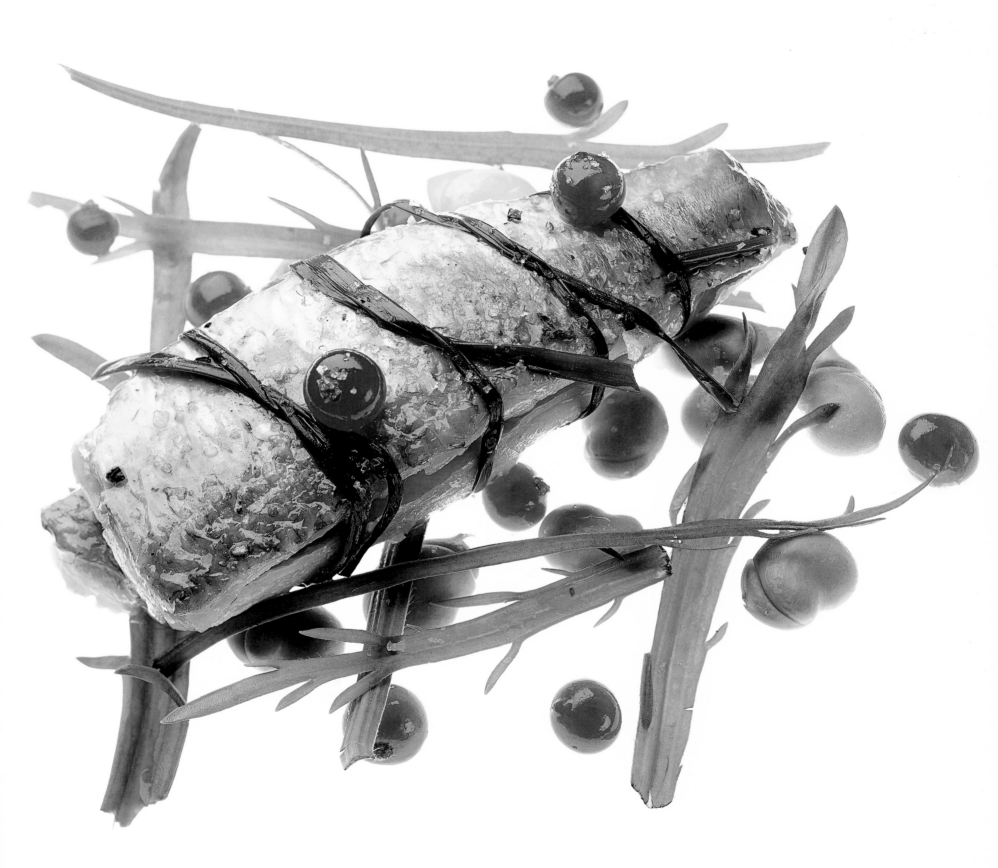

Slice of tuna, grilled
red pepper, and
braised baby fennel.

SOFTY.

Tuna doesn't have much luck in France; aside from the Basques, who do things their own way, people cook it badly, too fast, and without reverence. I cook it at a very low temperature, for more than two hours. That's all. I think that these days, a chef really impresses his patrons more with skill than with hard-to-find ingredients. (The precise handling of these ingredients can make all the difference.) The result might even be extraordinary. It is the T moment, the quintessence of tuna. That is all.

John Dory and
it's crispy skin,
pan-roasted potatoes
with thyme, and
a deep-fried sprig
of thyme.

STAY IN LINE.

182

One often forgets that thirty years ago the John Dory didn't interest anyone. No doubt, its recent success is due to the enigmatic game of trends and its Gallic name, Saint-Pierre, which has made things somewhat easier for it. Less fortunate fish (black pollock, plaice) trail their unglamorous names like millstones. Anyway, that doesn't resolve its behavior on a plate. Certainly it has a very briny skin—the taste is almost intolerable—but a dish is not a monologue. We need to strike. Here we have a pan-roasted potato in chicken stock. Why combine the sea with flavors from the earth? Simply because this interface has been around forever. For example, oysters with sausages. Admittedly, some combinations are not always happy; but here, the John Dory holds its own. It remains the axis of the recipe, and now the dish can turn.

Cherry tomato, turnip,
radish, and onion
with chervil leaves.

Nighttime Hold-up.

184

To each vegetable, its own way of preparation: the onion has been cooked slowly in butter, the turnip braised, the tomato slowly transformed into a confit. The tomato's great wealth is not just its pulp, but also its peel, and above all else its juices. They are what links it back to the earth. The tomato must be cooked, so slowly that any changes go unnoticed. The skin becomes its protection, its cooking vessel. It is now up to the cook to instigate the abduction of all the flavors.

Roasted loin of
turbot and a slice
of pear, surrounded
by very thin slices
of cucumber.

RESPECT THE DAWN.

186

Sometimes I despair over the mindless mishandling of seafood. Fishermen rise at dawn to bring us the freshness of the sea, brokers deliver the fish in a speedy fashion, and then, through ignorance or lack of attention, we kill the fish a second time in the kitchen. How fish, in this instance turbot, is cooked is crucial. If the heat is too high, the cells of the fish explode, and it loses its delicate juices and becomes dry. If the heat is too low, the flesh falls apart. Some prefer young turbot, which is more flavorful, while large turbot, thanks to the thickness of its flesh, can be enjoyed like a steak.

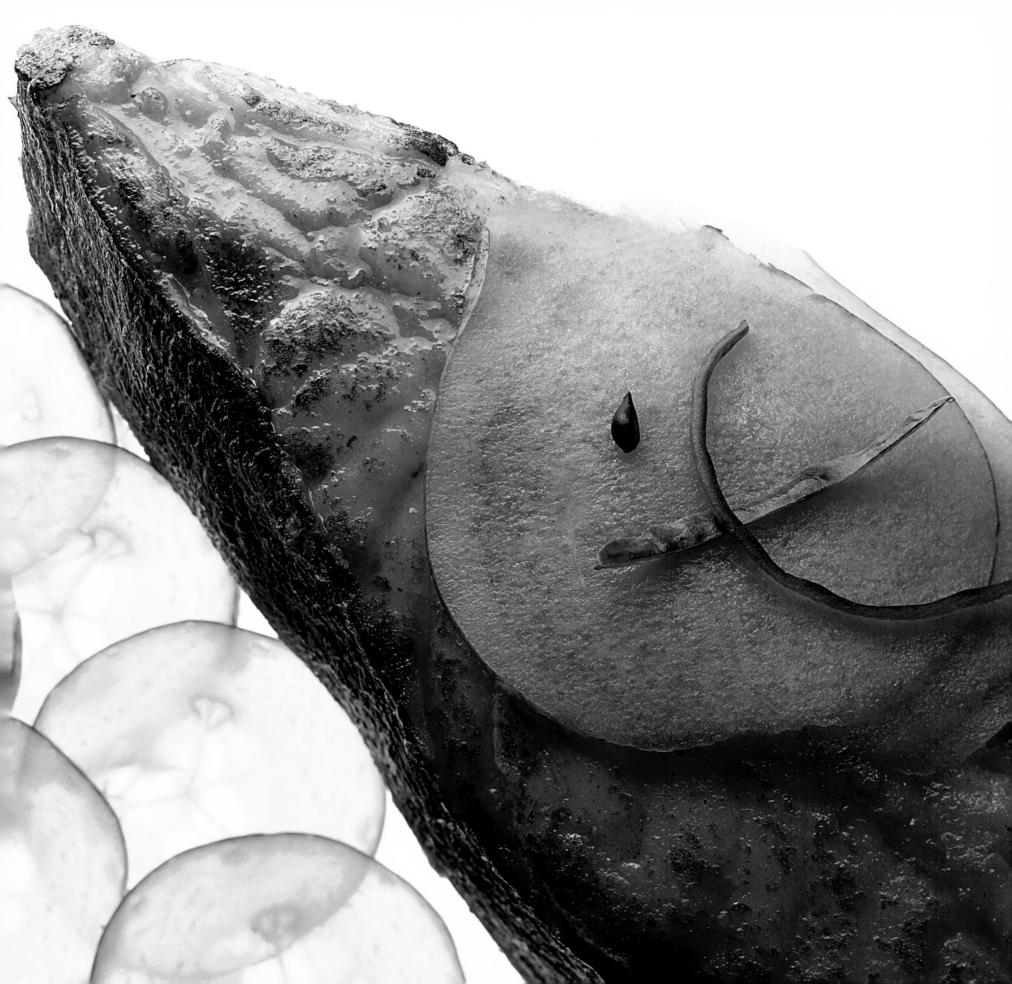

Jumbo shrimp and
onion marinated
in parsley and garlic
olive oil.

TROUBLE WITH DISHONESTY.

188

L et's be honest. This shrimp is frozen. Oh, I know, that's not good. Not good at all. What can I say? It is still excellent, and you cannot get shrimp any other way. It is caught, then frozen immediately on the boat. Is this dishonest? I don't know—it's too late to ask, and shrimp are too wonderful. Could it be that its shell has protected it through its frozen journey? Is it its texture? In any case, the flesh is perfect and has not suffered freezer burn, as so often happens with fish. When you have a product like this, you go straight to the point, straight to its essence: olive oil, lemon, pistachio oil, scallions blended with chervil. On a slice of toasted bread, it is delicious.

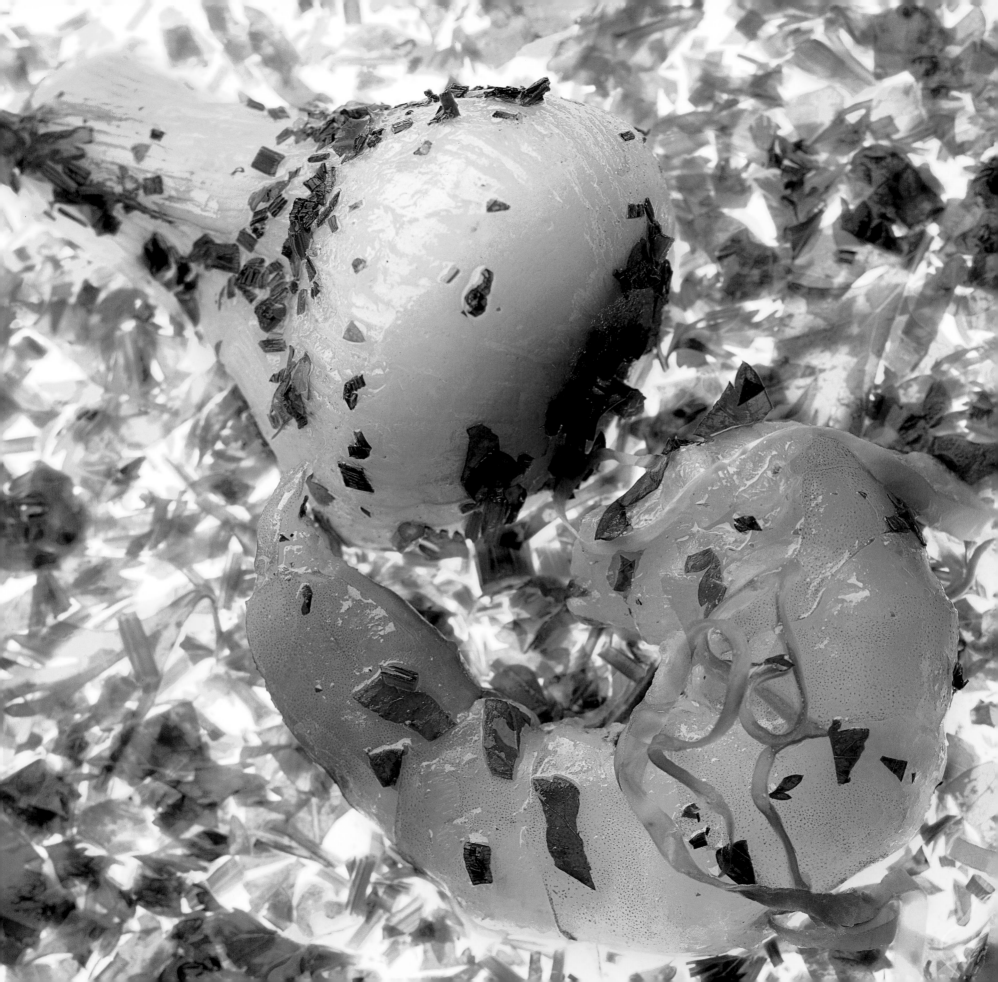

Vibrant salad combining grilled red pepper, garlic confit in its skin, tomato, and a wedge of orange.

AWKWARD SILENCES.

190

When you begin describing a creation like this grilled red pepper—roasted whole in the oven, with fresh tomato and sliced garlic—the diners listen benevolently; their appetites are stirred. But then, when you mention the garlic, something funny happens. There is an awkward silence. Even though garlic is one of the essential foundations of our cuisine, our culture does not welcome it. All because we're worried about our breath. Yet the very people who stay away from it for this slight inconvenience are the ones who praise it for its virtues—it's extremely good for you. Garlic doesn't stand roughness. It must be used like salt, ginger, or mustard. Don't let it dominate the dish; slip it in subtly, even if that sometimes means letting it move up to the front, as in an alliance of truffles and blanched garlic. It finds its place. It frolics and dances with lobster, wasabi, rice vinegar, and ginger.

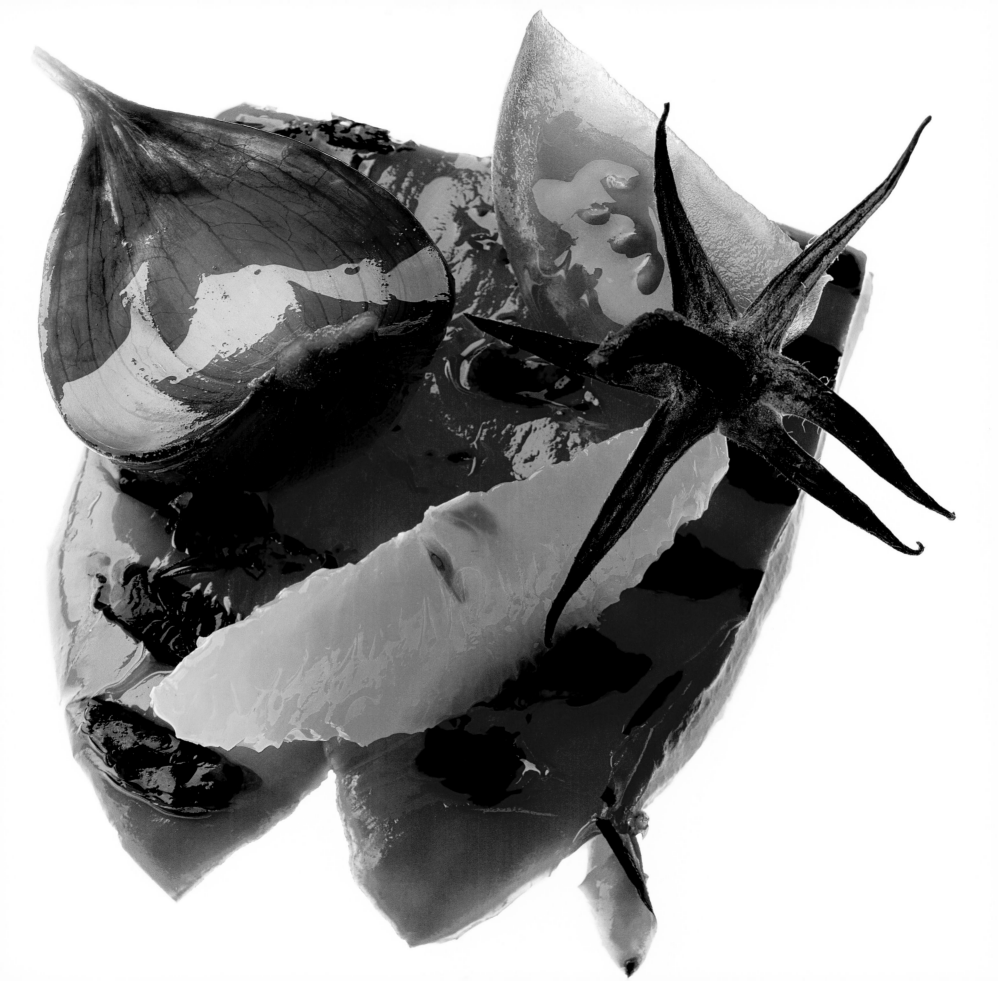

Veal tartare,
langoustine, and
dorade royale (delicate
white-fleshed fish),
surrounded by young
glazed leeks and a leaf
of purslane, tarragon,
and oreille du diable.

THE TRUTH IN FLIGHT.

192

Sometimes a dish goes round and round, looking for itself, cutting back, starting again. Quite often, you have to subtract ingredients to get to its real character, the truth of its essence. Other times, in a curious paradox, you have to add to get to the truth. Here is a veal tartare, langoustine, and dorade royale with purslane leaves, baby leeks… Another time, it might be sweetbread that, rushing to the front, finds its way.

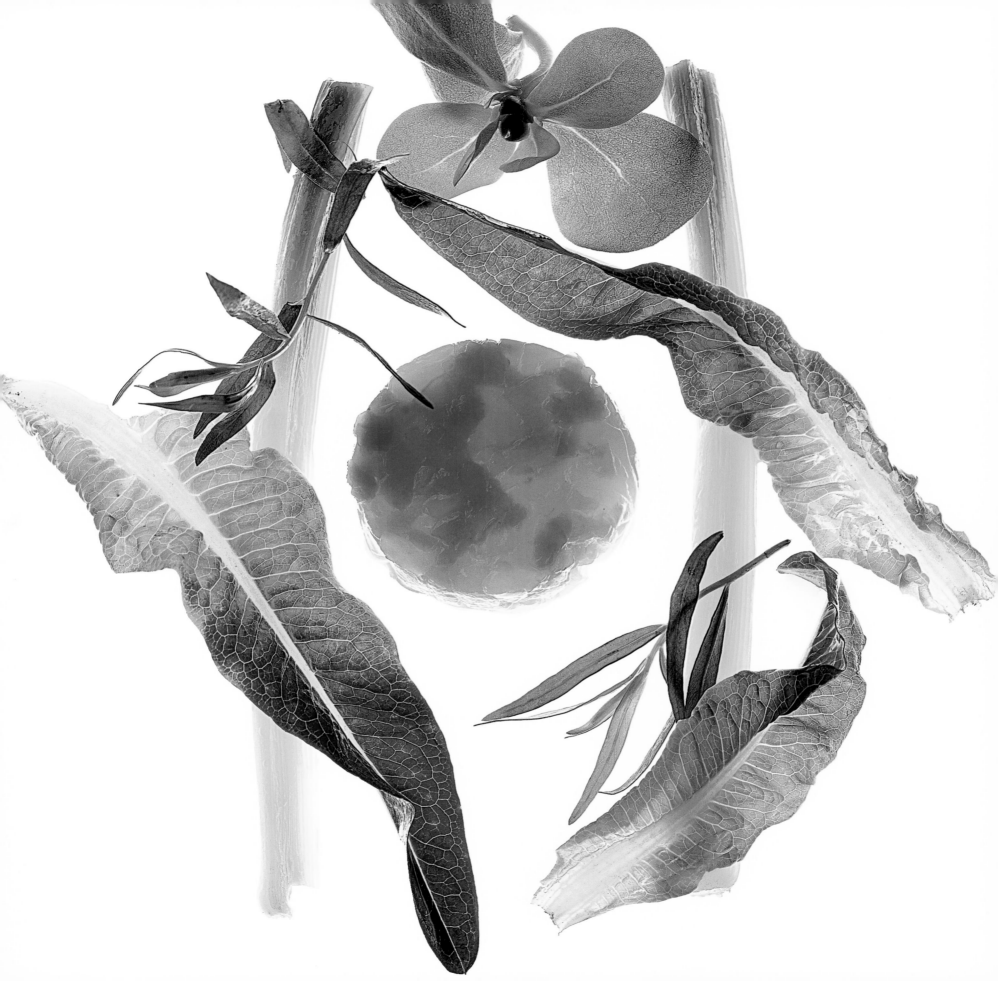

Insignificant.

194

The appetite is a fragile, delicate thing; it has its limits. A dish should always be mindful of that. There is no virtue in adding volume, quantity, and pointless extras. Perhaps this pizza and its tomato confit may be considered superfluous. Why not go directly to the main point: the haricots verts, the lamb. And yet, this apparently insignificant pizza gives another dimension to the haricots verts. Taking the place of a vinaigrette, it steals the show.

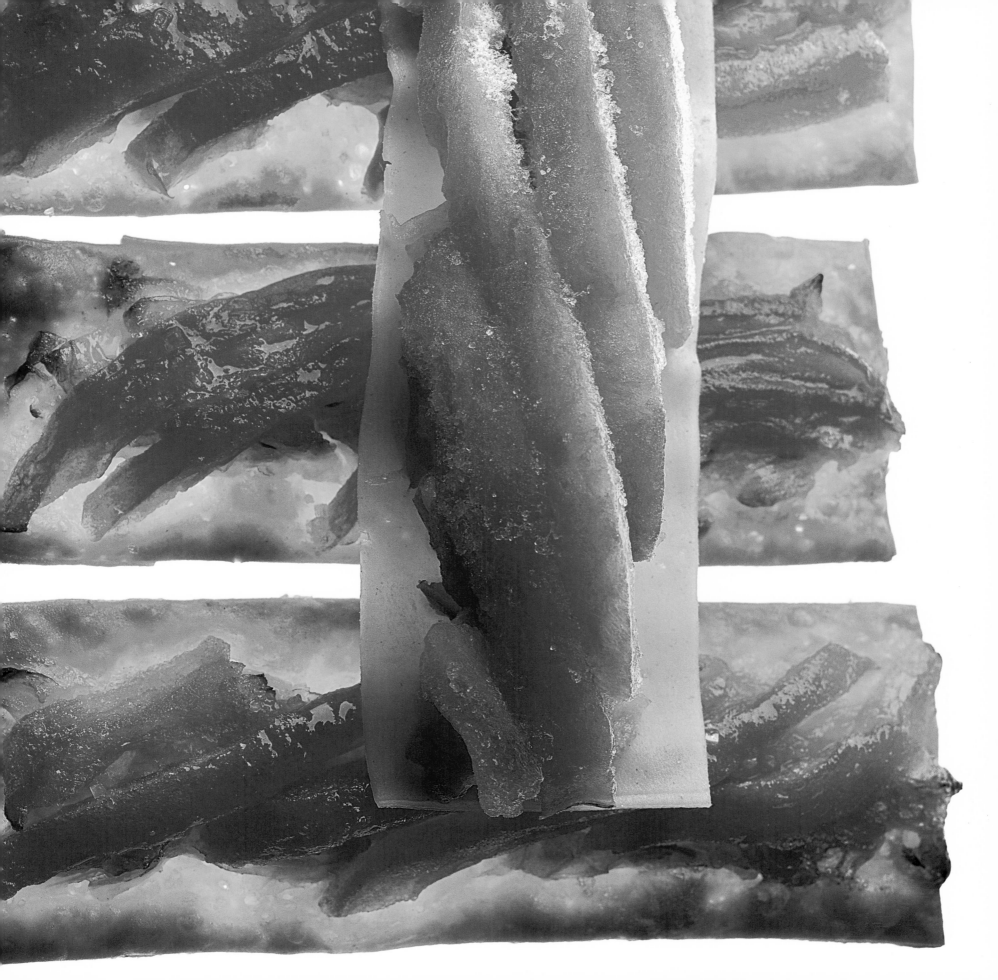

At Once.

Often, when we adopt ideas from foreign cuisines, our enthusiasm for borrowing carries us away, and we forget basic techniques. Pastilla, risotto, and — as here — tempura must respect the principles of the original dish. Once you have followed the basic alphabet, you may then stray. This monkfish is dressed as tempura; nothing on earth would tempt me to transform it into a beignet. The distinction is vital; tempura enlivens the ingredient, it doesn't let it become heavy and greasy. With this version, I know, I am well within my element. There is this immediacy (the dish should be served immediately and eaten within two minutes), a crispiness, and respect for the fish: the monkfish remains pearly and hot. I feel that this dish returns the fish to its true identity. A dish is a little like a photograph. There's one perfect moment when the balance is right; the result is not under or overexposed.

On Chinese cabbage
leaves, seared slices
of white tuna paired
with thin slices of lomo
and juniper berries.

SLOWING DOWN.

198

These strips of tuna and slices of lomo (pork loin) make a very peculiar duo. Yet one hesitates to break up such a superb harmony. We should be able to savor it without the betrayal of the blade of a knife or the prongs of a fork. It may be why my attention, in this composition, quickly focused on the cabbage and its ability to slow down the tempo, the gestures, and flavors. Here the cabbage takes up the role of the fat in some classic recipes. It coats the mouth and delivers its flavors while magnifying the essence of the other elements and allowing them to linger on the palate.

Tourteau crabmeat
with raw artichokes and
minced snow peas.

Never Hot.

200

I prefer the large tourteau crab over the spider crab, despite the reputation of the latter. The spider crab requires some attention and preparation to become a masterpiece. On the other hand, the tourteau can strut its stuff with little assistance: everything follows its lead (crème fraîche, olive oil, crushed peppercorn dressing). It should be served cold. I love seafood and crustaceans for their refreshing diversity. You can enjoy them for their sweet meats, but reaching for the coral hidden within the heads of langoustines is, for me, pure culinary delight. I wonder if our busy modern lives leave us enough time to develop this rapport with nature. I like to have the luxury of taking my time, to explore an ingredient, to follow its lead.

Sautéed cèpe, leaves of epilobe, fresh almonds, and small clams in a tomato-shellfish broth.

Understanding.

202

Today, an element of the absurdity is invading the kitchen. A seasonal unrest governs the menus. So, when some ingredients arrive in a timely fashion and together, there is a slight sense of confusion. Like this cèpe, small clams, and leaves of epilobe. There are only two or three weeks in the year when this encounter is possible. It is not an exceptional dish but its magic comes from the precise moment when it can happen. Then, quietly I slip in a few indulging partners: drops of champagne, melted butter. . . .

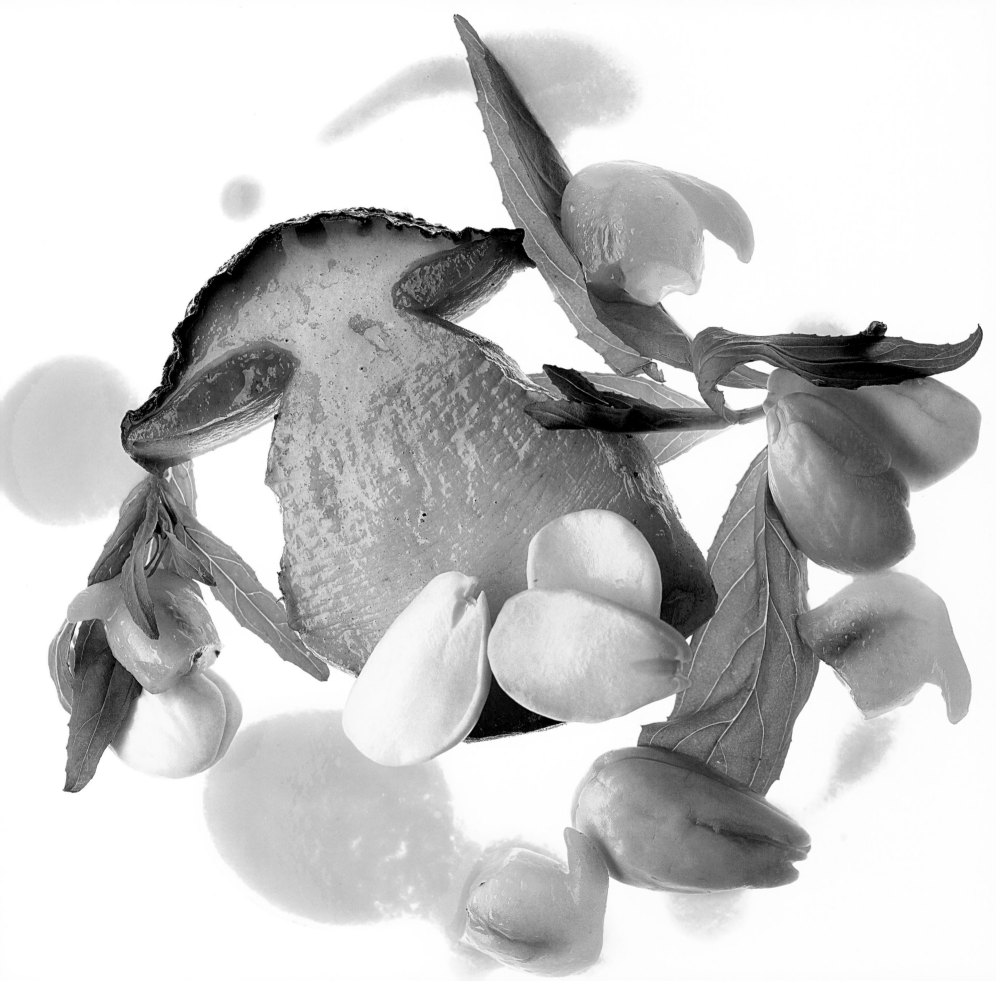

Very crisp sautéed
sweetbread, escorted
with grapefruit zest
confit and ribbons of
cucumbers

THE HAPPINESS OF THE NAUGHTY

204

Sweetbreads are the most Parisian of all dishes. It must be their impression of lightness (deceiving) while stepping purposely into gourmand territories. Here they were bathed with a fragrant butter of cinnamon and grapefruit zest confit, creating tender, soft, and succulent flavors with just a hint of sweetness. We even added few drops of Sauternes. This dish does not merely repeat its adjectives—tender, sweet, or moist. These attributes naughtily nestle themselves in the bitterness of the grapefruit and these thin slices of lightly blanched cucumber. One must remember to never let an ingredient run a monologue in front of its courtesans.

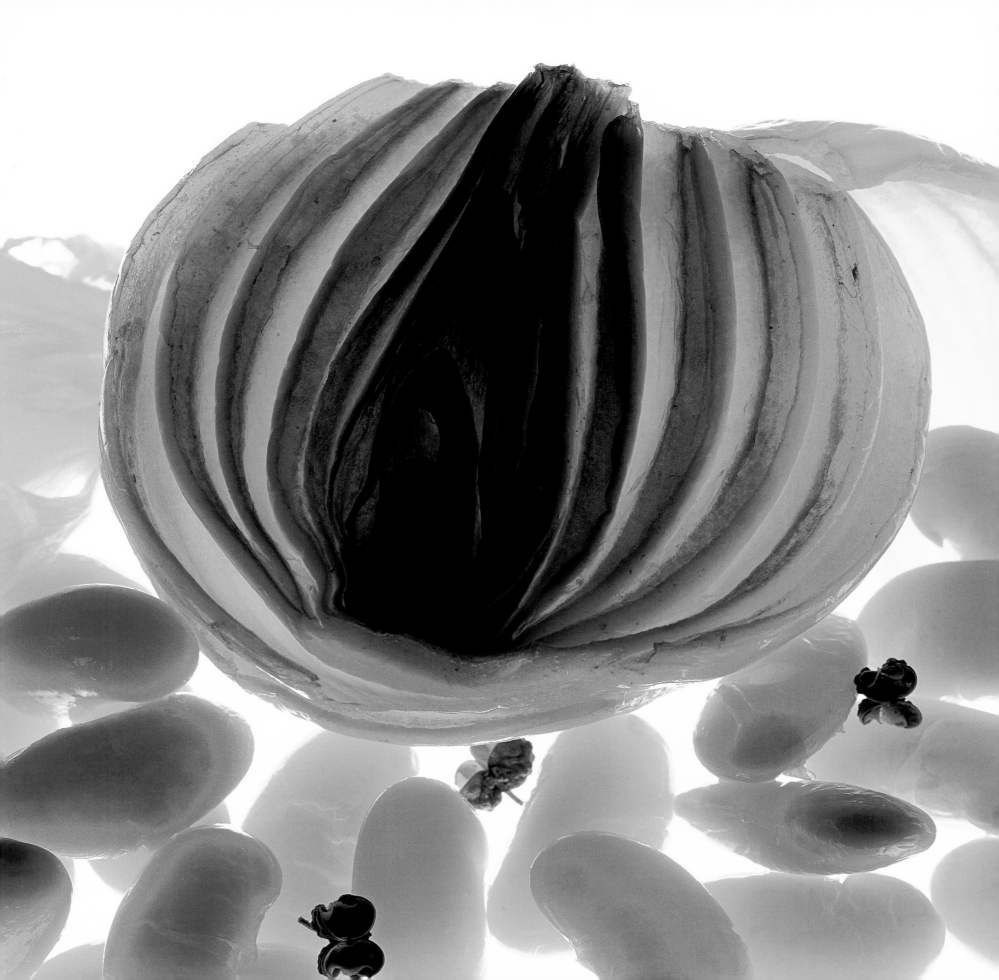

Fig, mirabelle plum,
grapes, and glazed
onion: fruits and
vegetables to serve
along the side
of venison, hare,
or bass.

RACKING MY BRAIN.

210

The main "noble" ingredient isn't necessarily the start of a dish: venison, sea bass, or hare. It could just as well be the roasted fig, the bay leaf, or grapes. All through my life as a cook, I constantly have been reminded of this fundamental disorder, this magical conversation among ingredients, all of them participating. Taste and flavors prevail; there is no hierarchy. It is the gathering of the right ingredients that create a dish. This is why I was always racking my brain to name my dishes. What people perceive as poetry was a mere desire for order and clarity. Now, I have embarked on a stricter system. When a lobster becomes part of a dish, it is lobster that has settled solidly there. It no longer drifts in a romantic alchemy, but takes up an angle of attack.

Duck breast and its
lacquered crisp skin,
papaya condiment,
and a lacy tuile made
of honey.

FADING OUT.

212

I n this dish, you can find the entire philosophy of my work. The duck genuinely evokes a dance. I have put it through everything, I have truly opened it up to release its spirit. The breast is roasted, then boned, then cut into salmis. I have toyed with the skin, glazing it, rendering a musical crispiness. I am particularly fond of this approach to a dish; you are immediately at its heart. It is dazzling, even resonant—the jazzy side of my cooking, with its dissonance, its rhythm, its direct approach to a theme. The flavors revolve in a loop, and then the sauce calms the melody. In the end, the dish fades out like a jazz tune—the music quiets down, the instruments stop shaking their hips.

Roasted saddle of
hare accompanied
by red currants
and carrot tart.

WHITE WATER.

214

Up to now, this saddle of hare was in its own environment. It has been roasted in goose fat. How then has this carrot tart found its way here? One sometimes has the feeling that the elements of a dish are like the salmon that fight their way heroically back up river, leaping over barriers, eluding fishers. . . . Even so, the answer seems straightforward, almost obvious. Game loves the company of fruit purées (quince, apple), sugary notes (bilberries). Thus, by strict logic, here is the carrot tart with its creamy filling. The pastry contributes some crunch.

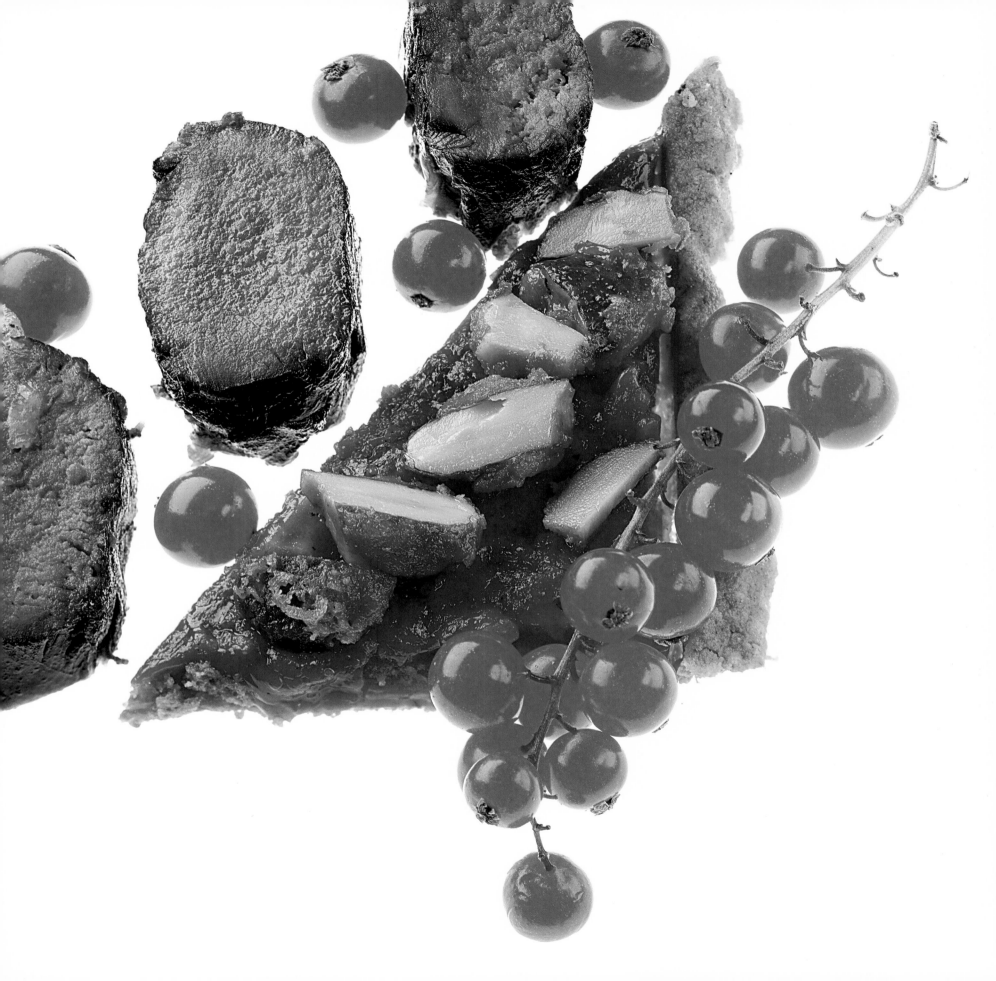

Saddle of lamb with
glazed carrots,
beet juice, and
shredded potato and
carrot cake.

THE CUSTOMER IS NOT ALWAYS RIGHT.

216

Always in the spirit of getting to the truth of a dish, I am particularly fond of slicing lamb very thin, to bring out all its elegance. I also cook it at a low temperature to preserve its delicate character. The lamb is served pink, and I am afraid that I am not interested in listening to a patron tell me otherwise. After all, I know this meat intimately. I have sought it out, I have worked with it, waited, watched. For twenty, thirty years I have labored over its texture, its cut, the way it's cooked. I believe a chef should be granted his point of view. The slice of lamb will be served pink because that is how I envision it. Do you ask a patron how he wants his fish cooked?

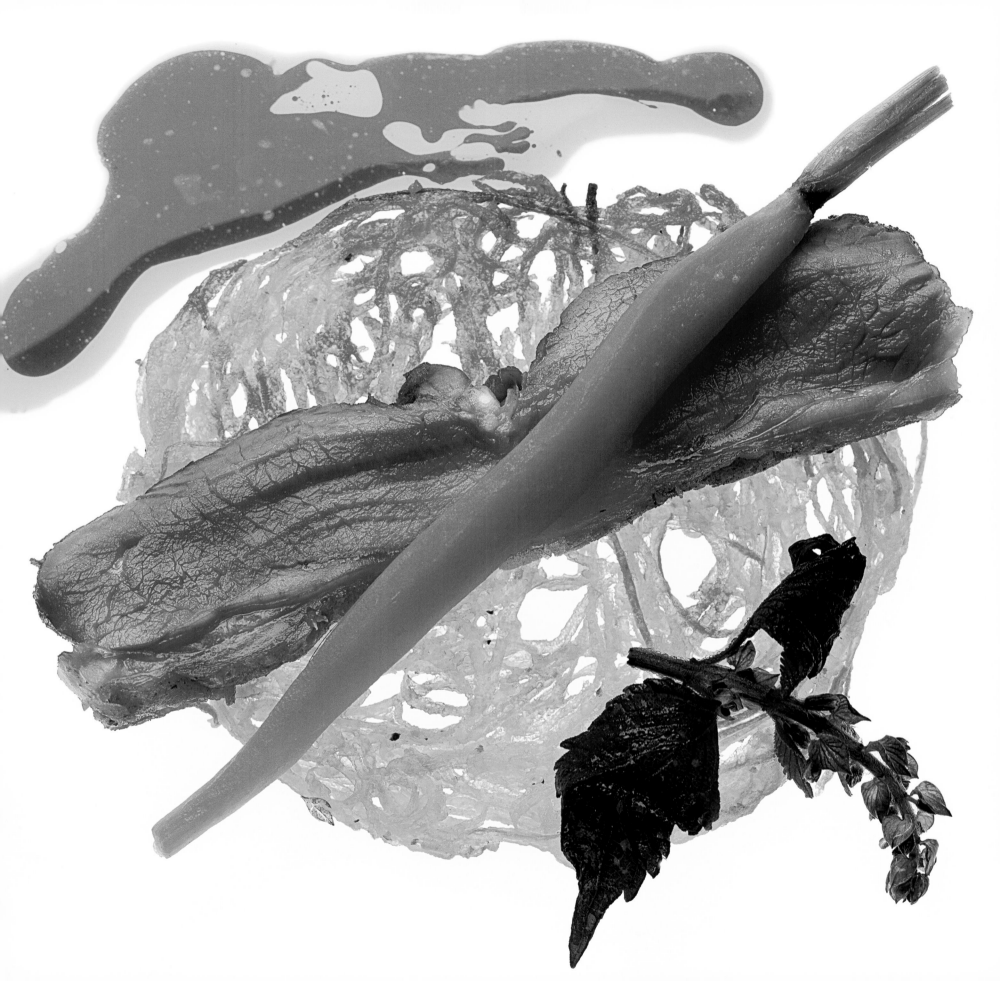

Green mango and its
skin, leaf of sorrel and
small chanterelles:
to serve with a white
meat or crayfish.

A DREAM.

Sometimes I no longer recognize a dish. I'm looking at this photograph. I can't bring the memory back. What was I doing on that day? What was the season? September? I see the green mango. What I see is the magical confusion of cooking. There are moments when the dish eludes you completely. You go blank. I imagine that the same occurs in writing or painting. You feel as if you are weightless, drifting. You want to calm the confusion, the disorder in your head. Everything escapes you—but then strangely, a few minutes, a few lines later, all of a sudden you're back on track. Was the dish a success or a failure? The answer is about to appear. You were in a dream, and here is reality again. Mango and its acidity, the leaves of tangy sorrel. I have it! It's an invitation for crayfish, poultry, grilled veal, carrots caramelized in honey. . . .

Rack of pork roasted,
braised, sliced,
grilled, and enclosed
into a papillote
with garlic, tomato,
and lemon thyme.

SOLITAIRE.

220

Sometimes an ingredient expresses itself in its extreme simplicity. You have to capture it, get to its essense as quickly as possible, like a syllable, a breath of air. Others require long hand-to-hand combat, as if their integrity is buried in their depths. I don't know how much time we spend on this rack of pork, but it is mind-boggling. We roast it on the bone, braise it, let it rest. We season it, we leave it in vegetable broth. And then we start cooking it again with sage, thyme, and a bay leaf. Just before serving, it is sliced and grilled again. Finally, we wrap it in parchment paper with fresh vegetables, garlic, tomatoes, and lemon thyme. . . . This is the intimate stage of cooking. Only then is it served.

Lamb from the North,
lamb from the South,
endives or olives?
Cooked perfectly pink,
it takes on both,
escorted by an herb jus.

EXPRESSWAY.

222

With meat, you have to get straight to the point to capture it. This is why my approach is very straightforward: roasting on the bone cooked wrapped in a layer of fat. It took twenty minutes for this saddle of lamb. That is the start of the dish, and everything else follows: the Sicilian olives, poached endives. . . .

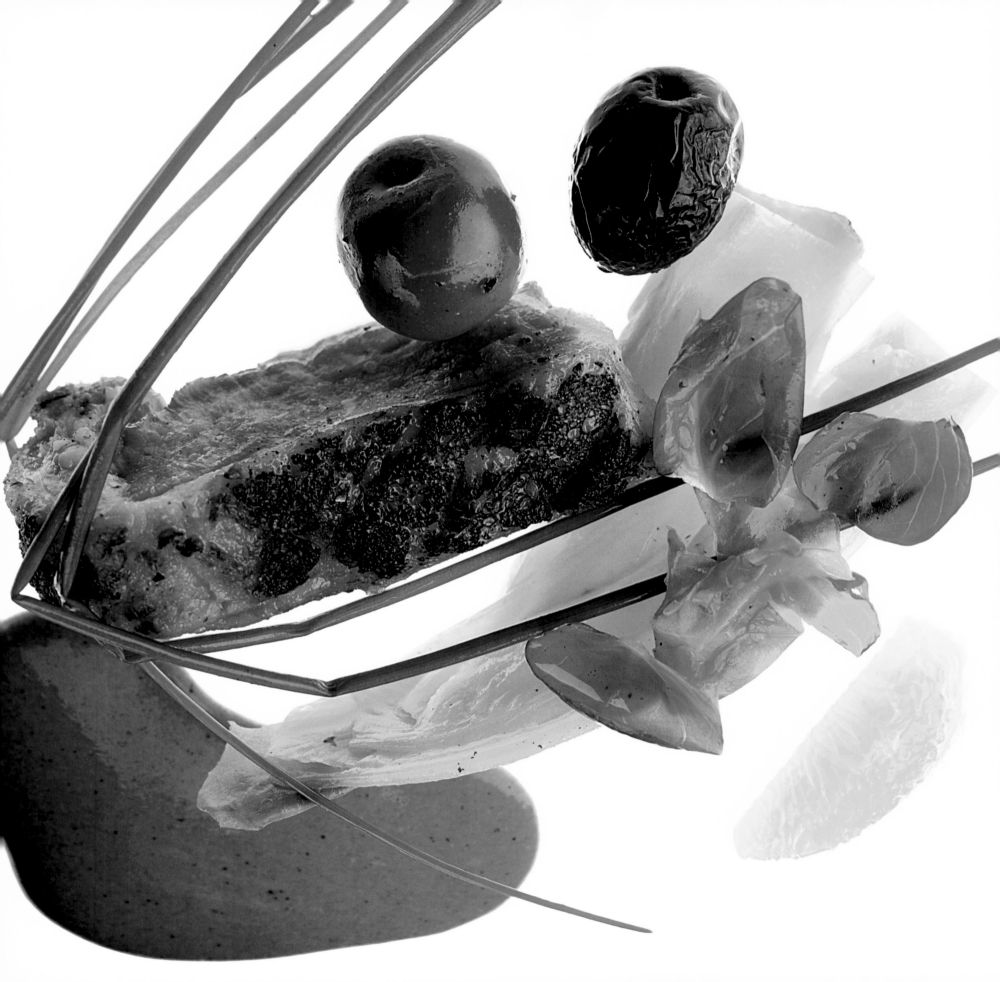

An assortment of
tomatoes in papillote,
in the company
of fresh rosemary.

The Veils Of Clarity.

224

Back in the kitchen, sometimes when we set out to prepare a simple dish, we are riddled with doubts. What if we didn't understand? What if we didn't capture the singularity and limpid character of these six varieties of tomatoes? What if our maître d' didn't have the exact information? When a plate is set out this way, it must be delivered by hand; the maître d' must set it on the table as if it were a surprise guest. With a gentle clarity, he raises the minimalist veil and allows simplicity to speak.

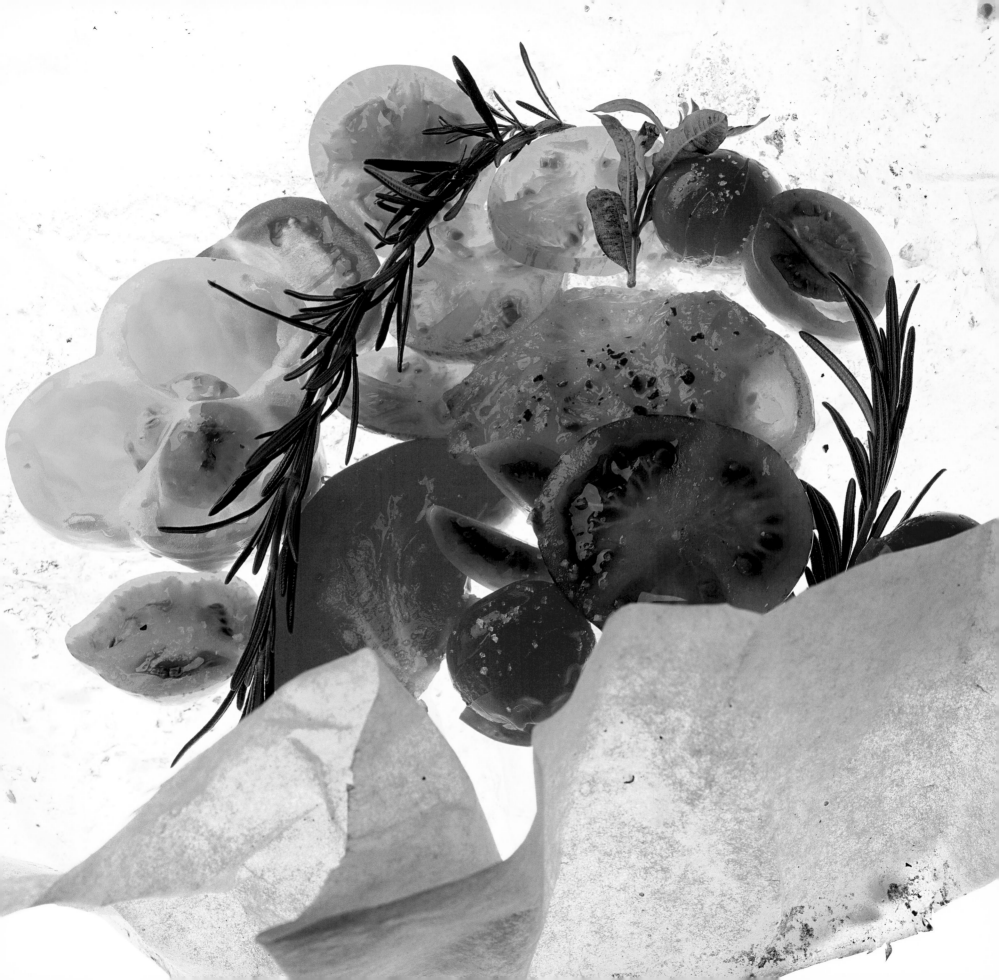

TRUSTY TABLES.

226

The season for this pairing is so fleeting, it is almost unreal. These gooseberries are like gastronomical phantoms. One or two weeks, and they're gone. Under these conditions, it is almost impossible to slip them into a menu. But it's equally difficult not to invite them to the dance. There they are. But the chef also needs to be there to make them join the party. Here, sautéed in olive oil, they sit in a pool of avocado cream sauce. They may be paired with a steak. This kind of creation never appears on the menu, but I serve it to what I call "my trusty tables." I know they are waiting with an open appetite, and curiosity. They are seeking elusive thrills and will welcome these exquisite phantoms.

TOO COLD.

228

A patron once remarked to the maître d' after tasting a game terrine, "It's perfect, but too cold." The maître d' came back to the kitchen, laughing, and told us the story. And yet the woman was absolutely right. There are as many degrees of cold as there are of heat. This chaud-froid of poultry would be ruined if served too cold. On the other hand, I prefer when a terrine of foie gras is very cold, breaking under the blade of a knife. Serve it too warm and it becomes overwhelming. It settles down on the palate and remains for the rest of the meal.

Roasted apricot, chanterelles, fresh almonds, apricot juice, and red orache: a symphony for langoustines or veal curry.

ANXIOUS IMPATIENCE.

Here they are on the departing dock: an irresistible salad, the red velvety orach, apricot roasted in butter and brown sugar, and chanterelles. I love to watch their impatience. Someone is waiting for them, but who? I can almost feel their anxious impatience, their lazy innocence. I'll let them dance, I'll set them up with sole, or even wonderful grilled langoustines. A little sautée of curried veal. . . . I don't see myself playing it safe, making something predictable. Part of me is always trying, maybe even with mild desperation, to court danger, to be rash. I would like this dish to remain open to possibility, to be ready to head in a new direction. At some point, alas, a certain dish will close up, solidify. It will become a success, but its spirit will be dead. That's when I'll take it off the menu.

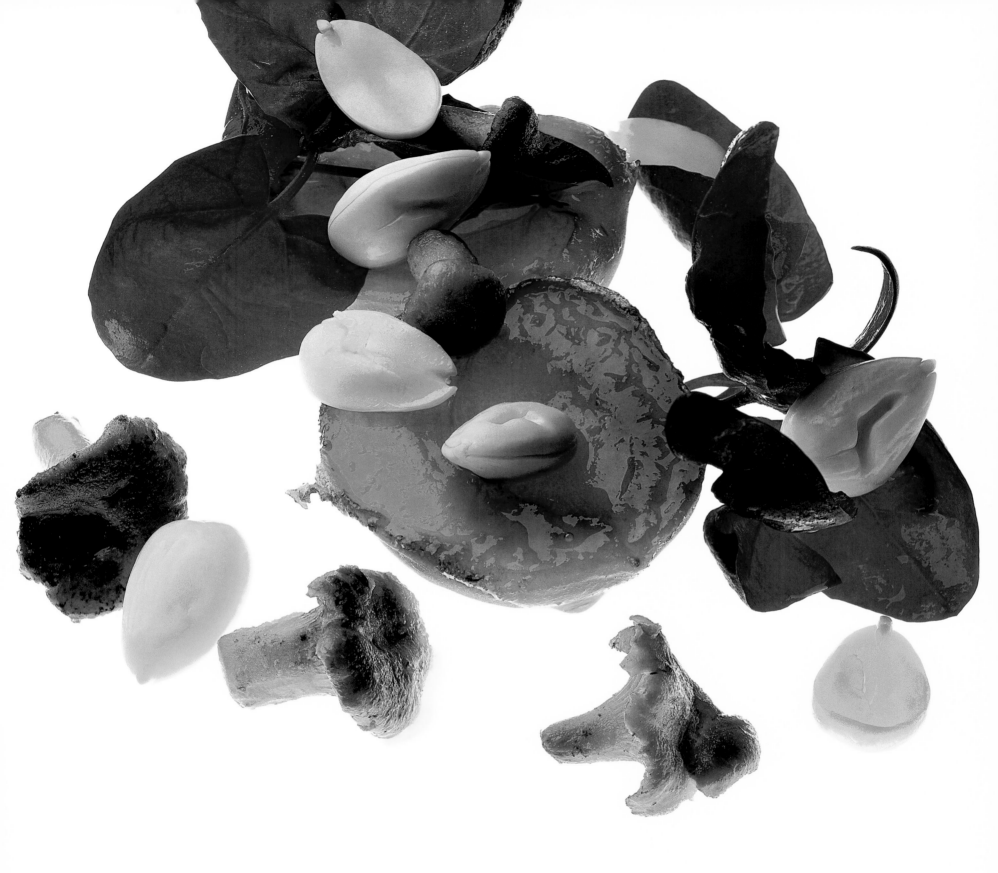

Tête de Moine
cheese shaved into
airy curls paired
with grissini
wafers made of chick-
pea flour
and peanuts.

IMPULSIVE.

232

The cheese course in a degustation, or tasting menu, is always a little paradoxical: the hunger has abated while the cheeses demand an appetite. The palate has already been stimulated enough before this course's strong, powerful flavors challenge it again. And yet, cheese lovers are entitled to expect a response to their desires. Here, I use Tête de Moine, a raw cow's-milk cheese from Switzerland, in this spirit, endeavoring to bring a touch of lightness with a sort of grissini prepared with chickpea flour and ground peanuts. Without a doubt, the bitterness, fat, and sugar is what is needed to give this cheese a new dimension. Always searching, never resting on your laurels tinkering the hours away, you must remain impulsive. Weariness and routine must never invade a dish.

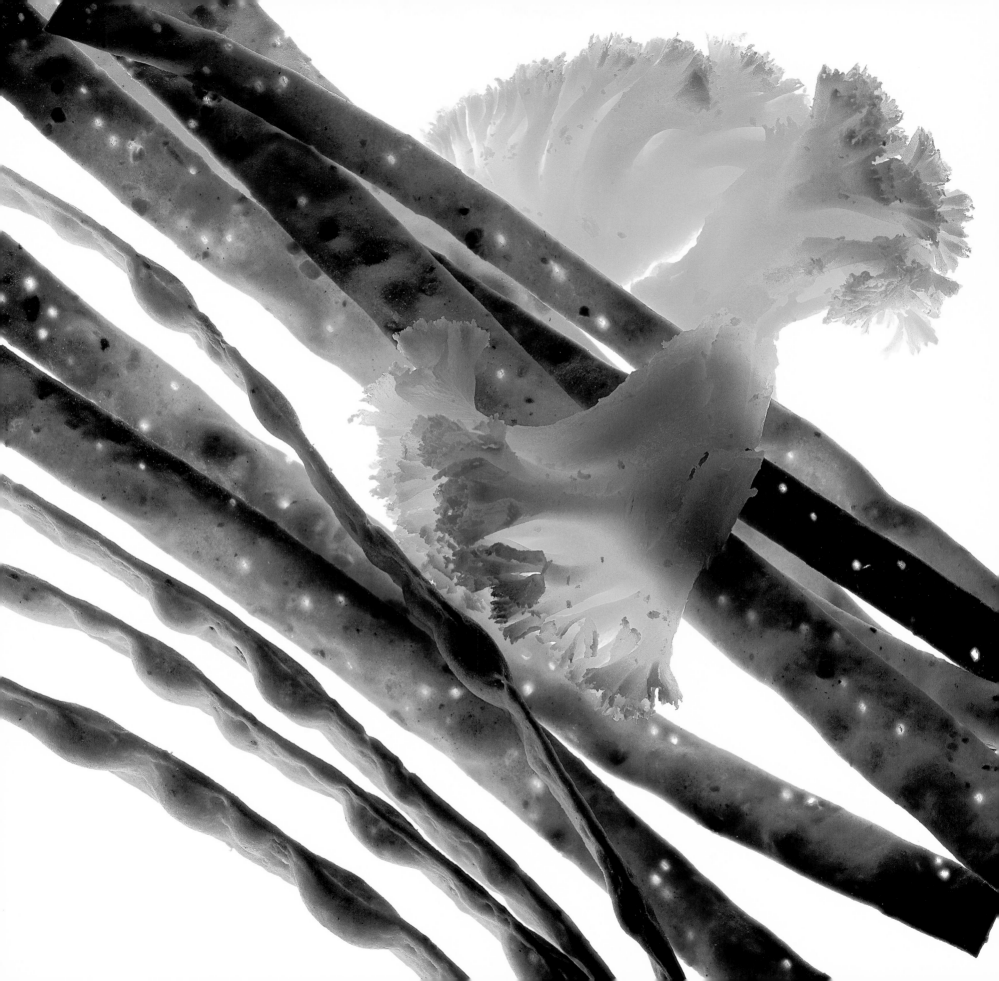

Roquefort with one of
its most delicious
counterparts: green
apple paste.

The Resources Of Solitude.

234

The rather unrewarding fate that awaits cheeses during a meal at a restaurant is in the end a godsend. Here we have a subdued piece of cheese that has been reinvented, followed, taken to its limit. In the kitchen it became more inviting: cream, crackers, breads, green apple. It stood at the end of the dance floor and is now in the center. Watch it dance playfully. The cheese is ready for its entrance into the meal ahead of the desserts. It's not just a victory, it's a revenge.

Since 1990, **Bénédict Beaugé** has been a culinary contributor to many magazines including *Marie-Claire*, *L'Événement du Jeudi*, *Air-France Madame*, *Slow*, *Cuisine du Terroir*, and *L'Armateur de Bordeaux*. He has written many books, including *Aventures de la cuisine Française, une histoire de la cuisine Francaise contemporaine, de 1960 à nos jours* (NIL Editions), and *La cuisine acidulée de Michel Troisgros*, in collaboration with Michel Troisgros (Le Cherche Midi, 2002).

Food critic and journalist for *Le Figaro*, **François Simon**, is the author of many books, including *52 weeks in Europe* (Assouline, 1999), *Miam Miaou, recettes pour chat moderne* (Noésis, 2002), *Comment se faire passer pour un critique gastronomique sans rien y connaitre* (Albin Michel, 2001), *Manger est un sentiment* (Belfond, 2003). He is a contributor to *Vogue*, *Casa Brutus* (Japan), and *Rive Droite Rive Gauche* on *Paris Première*.

In 1963, **Jean-Louis Bloch-Lainé**, joined *Elle* magazine where he worked under the direction of Peter Knapp. He became a contributor to *Marie-Claire* in the early 70s, where he stayed for over twenty years. He is the photographer of many books including *La Riviera d'Alain Ducasse* (Albin Michel, 1997), *Saveur du Japon d'Hirohisa Koyama* (Albin Michel, 1998) and *Secrets Gourmands de Pierre Hermé* (Larousse, 1994)

Artistic Director and designer, **Yan Pennor**'s has produced the culinary pages of *Marie Claire*, and has contributed to about thirty magazines, including *Rolling Stone* where he was the editor. He was the artistic director of *La Riviera d'Alain Ducasse* (Albin Michel, 1997), *Saveur du Japon d'Hirohisa Koyama* (Albin Michel, 1998) and oversaw the concept and editing of *Secrets Gourmands de Pierre Hermé* (Larousse, 1994). In 1992, he received, in Seville, the Grand Prix du Design de la Communauté Européenne.

Journalist and writer, **Marianne Comolli**, is a contributor to *Cosmopolitan* and *Psychologies Magazine*. She has published many books including *Saveur du Japon d'Hirohisa Koyama* (Albin Michel, 1998) and *Secrets Gourmands de Pierre Hermé* (Larousse, 1994) and collaborated with her sisters on *La Cuisine des Parfums* (Chêne, 1996)